MW00463236

DO YOU SEE THIS WOMAN?

LUKE 7:44

The Believer's Guide to Domestic Violence & Abuse

by ELIZABETH WHITFIELD SHERRELL

Copyright © 2011 by Elizabeth Sherrell
All rights reserved.

Foreword by Dr. Judy Fiorentino

All Scripture quotations are from the King James Version of the Bible.

Copyright TXu 1-629-842 2009.

ISBN: 978-0-615-48342-9

First Printing

FOREWORD

BY JUDY FIORENTINO

*A*s we look around us and listen to the news, we are jolted with the hard facts that the "end time" is near at hand. The signs of time speak of violence, cruelty, brutality, viciousness, etc. All these signs are summed up in one word: ungodliness.

Domestic Violence is an epidemic rampage of satan against the basic unit of the Church, the family. The family is God's holy idea of what a Godly life is supposed to be. Now, at this age, the family is terrorized from out of its very foundation. The essence of family is love. The heart, soul, and spirit of a family is the bond established by God to manifest His perfect and true love, His unconditional love. However, love, the very core of a family, has been deviously used to manipulate, coerce, and abuse family members.

Violence in many countries is a crime. More importantly, believers need to know that domestic violence is evil. It is an atrocity, an abomination, a sin, and a heinous work of the devil. **Batterers must know that what they are doing is a catastrophic sin** that will take them to the den of iniquity, hell. Victims must know that God does not expect them to live in abusive homes or tolerate abusive relationships. Because James 3:16 reminds us that, "For where envying and strife is, there is confusion and every evil work." All kinds of evil work is seen in domestic violence and the household members are

totally confused. Likewise, God does not want children to be raised in abusive homes. It is a direct contradiction of His very being: love, because God is love.

As a missionary evangelist, I have preached in fifty different countries as well as in almost every state in the United States. I have been a pastor for over thirty-two years, in education for over fifty years and a Christian Counselor for more than a decade. I am a survivor from domestic violence. Oh how I wish that I had had a pastor or someone with whom to share my personal heartaches. There was no one!

Thanks be to God, He never left me alone. He was always with me and the Holy Spirit drew me closer to a personal relationship to the Lord Jesus Christ. In Hosea 4:6, God's Word says that my people are destroyed for lack of knowledge. Believers, the time has come that we must take a stand against Domestic Violence. We must help the victims with understanding and compassion, and we must stop batterers.

This guide on Domestic Violence, *Do You See This Woman*, is a must for every believer and Church leader. It is one of the hallmarks of this present time. It focuses on the ultimate essential of the Bible's message of God's love for each and everyone. By focusing on God's meaning of love, believers will take domestic violence as a warning signal to the end times. Consequently, we will help stop satan from attacking families and end Domestic Violence.

Do You See This Woman is a superb accomplishment of a much needed instructional and informational book for today's dilemma. By using this guide, believers will be able to recognize a victim and also a batterer through listening and asking a few questions.

Judy Fiorentino, Ed. D., Th. D., Min. D., Ph. D.
President of Zoe University
Pastor of Zoe Chapel Church
Certified Christian Counselor

CONTENTS

PREFACE

uring the fourteen years of my first marriage I endured cycles of verbal abuse and emotional neglect. There were the good days of happiness. I clung to those. Then the tension would begin and soon the abuse would pull me down into despair. I remember feeling there was no way out; that I was losing myself somewhere in all the confusion. My husband felt his demands were biblical because he was the "head of the house." His ideas about religion and sexuality became distorted to the point that they no longer bore resemblance to the character of the man I married. That man had dedicated himself to ministry. That man expressed love and purpose in life. This man put his work and friends ahead of marriage, the children and God. I was barely able to keep my sanity. In a few short years the good times no longer outweighed the bad.

In our thirteenth year my husband announced we had lost our business. His poor management of paperwork had ended in a tax nightmare that threw us into bankruptcy. It took everything we had. I remember once having ten dollars for the week's groceries. I was fast losing hold on the faith I once had. Christian counsel failed me when a local minister himself propositioned me. I can still recall rushing out of his office in confusion and shock. Who could I turn to?

My husband's rages became more frequent. Then the hitting began. The first slap across my face was a surprise. The second one got my attention and the attention of my co-workers to my bruised and swollen face. I knew I could not stay. I had remained silent too

long and, I had sheltered the kids as much as I could; it would be hard to break this news.

Struggling most of the night, I laid my case before the Lord. Though I was not without sin and I knew God hated divorce, I also fully believed He would make a way of escape from this madness. About three in the morning I came to a place of peace and made a tentative plan to leave. Fortunately for me and the children, it worked. I still remember the fear that lodged in my throat as I drove across town. I also remember how deeply I slept that first night. The good sleep did not last however; it was soon replaced by constant anxiety and a nagging, unfounded guilt.

The next surprise came through my own pastor. The support of this Church had meant so much. I felt it would be good for my children to see their friends right now and I needed them too. After I settled into my usual group, I shared with them what had taken place in the last few days. They knew the abuse I had suffered often praying with me for guidance. I said I was filing for divorce. The group became quiet. My pastor slowly cleared his throat and the others looked uncomfortable. He leveled a look of sternness at me telling me that the Church did not support separation or divorce. He then said I would no longer be welcome there as long as I continued in sin. I was completely stunned. In a daze I gathered my two children and walked in silence to my car not daring to look back. Shame and confusion engulfed me. I did not try to contact anyone from the Church again.

My marriage was shattered and trust in the refuge of my Church family was now broken. For the next five years I struggled in my Christian walk. Decisions as a single mom were hard to make and were often wrong; not having a Church family or a pastor as a guide had left me wounded and vulnerable. I did not trust Christians, I did not trust myself and I found it very hard to trust God during those years.

This brief summary of my own pain is meant to bring you to an understanding of why I have such a compassion for women, especially Christian women, who find they are unable to survive in an abusive marriage. They often feel trapped by fear of exposure to a legalistic viewpoint. Unwelcome in some Church or community settings, they gradually

become the unseen, the ignored, the passed-over. Without a husband they are even perceived as a threat. They and their children quickly join the ranks of millions who are victims of prejudice and ignorance.

The focus of this book is to bring the pain of these women to light. Whether they are within or without the walls of the Church, the misunderstanding of their plight by the Church is what is being challenged in this book. As you read they will become visible. As you apply the compassionate Word of God they can be healed and drawn into the warmth of the fellowship of believers.

Acknowledgment for guidance and direction must first be made to my heavenly Father, my "Abba," who tenderly brought about my own restoration and has used my experience to bring hope and healing to other women who are victims. It is a great honor to counsel women and see them begin the road to recovery with God's help.

Tender thanks goes to Lamar, my husband of twenty-nine years. He is a gift from God and has brought his own brand of humor along with his three beautiful daughters into my life. He continues to lovingly support all that I reach for.

Great appreciation goes to my son, Chris and my daughter, Michelle, who recently lost their father to lung cancer. They each took their own difficult steps to hold onto a relationship with him in the years following our divorce. Our broken home brought them more pain than should ever have come their way yet, they have graciously held the door of their hearts open to me, to their father, to their step-dad and his daughters. They now are growing stable families of their own.

The women whose stories appear anonymously are unique and courageous. They have graciously allowed their stories to be a part of this book and I am thankful for the insight that will be gained through their sharing.

I also wish to thank Dr. Judy Fiorentino, Dr. Keith Powell and, Dr. Cynthia Anderson of Zoe University for believing in me and patiently encouraging me to continue working toward the completion of this book. Without their instruction, support and prayer it would not have been written.

"SIMON, SEEST THOU THIS WOMAN?"
(LUKE 7:44).

CHAPTER I

BLIND JUDGMENT: LUKE 7:44

*T*he scene that is painted of a woman called Mary in the gospel of Luke, chapter seven, is that of a "woman of the streets." She expected to be judged as a social outcast and a notorious sinner. The judgment she felt fits the perception that many Christians have of women who are victims of domestic violence and abuse. The scene describes how Jesus dealt with this judgment and is therefore a suitable backdrop to create a challenge to readers of this book.

It was a custom in that time that uninvited people from the street could come into a home after a certain time had elapsed during a feast. As Mary entered she saw Jesus and realized that no one had washed His feet. Quickly surveying the room she saw that all the servants were busy and no basins or towels were left. Then she remembered her own alabaster vase filled with oil and spices.

Dare she approach Him? Mary knew her own wounds of shame and uncleanness were hidden deep in her heart. Somehow she knew Jesus saw them. Nonetheless, His look of tenderness did not change toward her and His eyes conveyed forgiveness without a word.

She moved toward Him, pulling her veil from her head and

letting her hair loose as she walked. She broke the vase, pouring the contents of it upon the head and feet of Jesus. Then she tearfully knelt to wipe his feet with her own long hair. Simon, the host, was not pleased. Jesus perceived his thoughts and spoke to him. His words were not loud or harsh as He did the unthinkable and looked directly at Mary.

Looking up as He spoke, Mary recognized that it was her He beheld, not Simon. Direct eye contact with a woman in this manner was unheard of. He had purposefully honored her in the presence of her accuser! His words to Simon were compelling yet instructive and without condemnation, *"Simon, I have somewhat to say unto thee...seest thou this woman?"* Or, do you really see Mary, do you see her heart?

Mary's state of being wrongly judged represents the hopeless plight of millions of women who remain excluded from the Christian community because of a wrong perception. They are the invisible, the unseen, and the outcasts. Even when these women and children make a courageous attempt to become part of the community of believers around them, it remains a difficult process. It is easier to let them remain invisible, existing only in newspapers, books or statistics.

As you read this guide, allow yourself to remove preconceived ideas and open your heart to the women and their families caught in the awful devastation of domestic violence, homelessness, or abuse. Perhaps you have already done that. You may already deeply grieve over the violence in families, particularly Christian families. You may be greatly frustrated with the lack of adequate help for them or, of their poor acceptance in local Churches and communities around them. Suggestions in this book can be your first step to opening Church and other community doors that will lead to resources for the healing of victims and their abusers in the deadly game of domestic violence. *Further and, most importantly, it can be a resource to ways of <u>preventing</u> it from happening altogether!*

This book is meant to provoke the reader to reflect upon his or her own heart. Just as Jesus provoked Simon to search his heart for truth that could lead to a different perspective, this guide is meant to challenge you to also search your heart and ask God how you are to respond to women who are victims of domestic violence and abuse. The stories used in this guide are real. The names of the women in stories are not.

Ginger told the Emergency Room doctor that she slipped in the kitchen but the bruises and broken nose did not match her story; he had found older injuries. The doctor asked, "Is there something you need to tell me?" She whispered as her eyes betrayed her fear, "No." Days later a neighbor found Ginger bloody and beaten. Ginger explained she fell again and needed help. The neighbor dialed 911. She stayed with Ginger and her suspicions were confirmed. Ginger had been raped and beaten by her own husband!

"FOR IT WAS NOT AN ENEMY THAT
REPROACHED ME; THEN I COULD HAVE
BORNE IT: ...BUT IT WAS THOU, MINE
EQUAL, MY GUIDE, MINE ACQUAINTANCE...,"
(PSALM 55: 12-14)

CHAPTER II

THE INVISIBLE EPIDEMIC

*A*wareness brings knowledge and knowledge creates an environment for change. In any epidemic, those who can bring change must first acknowledge that a problem exists. They must then make it visible to those who can help resolve it. They must be open to becoming educated about the problem, also educating others appropriately in order to plan and implement action that will bring about a difference.

Domestic violence and abuse is an epidemic that has found an inroad into a large majority of families in America. It is no longer a problem that can be ignored. Prayerful pursuit of knowledge about these issues will lead to compassionate action. This is critical to the integrity of the fabric of the body of Christ here and in other nations around the world because many of these families are connected to Churches.

According to the National Domestic Violence Hotline, *domestic violence refers to a pattern of violent and coercive behavior in an intimate relationship exercised by one over another.* It includes at least one, or perhaps all four, of the recognized types of abuse: *Physical assault, sexual assault, psychological assault and assault against property belonging to the victim.*

Only in the last fifteen to twenty years has domestic violence and

abuse begun to be recognized as serious and challenging issues in American society. It is taking longer in third world countries though humankind has been in its grip for centuries.

In the book "Between Pit and Pedestal" by author's Marty Williams and Anne Echols, there is a conclusion drawn about violence against women in the middle ages and how men were tragically not held accountable.

> "Historian Judith Bennett believes the low number of reports of male violence against women was related to the fact that males controlled the courts. The result was that men who attacked women often went unpunished, while the female victims were censured for complaining and/or for inciting the assaults."[1]

Secular organizations have long heeded the problems of violence and abuse in the home. For years these organizations have tried many avenues to raise awareness of domestic violence against women,

> "...they have been trying to get men around them-and men in power-to do more about violence against women... yet even with all of these achievements, women have faced an uphill struggle in trying to make meaningful roads into male culture. Their goal has not been simply to listen to women's stories and truly hear them-although this is a critical first step. The truly vexing challenge has been getting men to actually go out and do something about the problem, in the form of educating and organizing other men in numbers great enough to prompt a real cultural shift."[2]

It is time the Church recognizes its call to open the avenue for true change by offering help rather than denial that the problem exists.

One purpose of this book is to raise awareness that domestic violence and abuse cases need to be addressed directly from the pulpit rather than left to secular initiatives or opinionated Church counsel.

1 Williams, Marty and Anne Echols. *Between Pit and Pedestal, Women in the Middle Ages*. Princeton, NJ: Markus Wiener Publishers, Inc. 1993, p. 164
2 Katz, Jackson. *The Macho Paradox*. Naperville, IL: 2005, p. 8

As the believers openly respond with tender care to their own who are victims, those who are hurting outside the Church will know there is truly a place of acceptance and healing at the feet of Jesus and among His people.

Domestic violence and abuse does not go away when it is ignored. In truth ignorance is condoning. The abuse will only escalate.

> "We can no longer afford to be indifferent to the need or to our responsibility to take appropriate action. In the first place, God's honor is at stake. Abusive marriage cannot possibly mirror Christ's love for the Church. Second, the peace of the Church is at stake. If there is violence in our homes, we cannot have tranquility in the Church. Further, we are failing Christian leaders and people alike. We have failed to provide guidance and correction where it is most needed, in families of faith and among families of Church leaders. We have failed the victims and we have failed their oppressors. We have not sought to offer the healing of Gilead or the justice God demands."[3]

Zero tolerance for abusive behavior can and should be a recognized standard, promoting the Church as well as secular organizations as safe places for those who need support. Support groups can allow and validate the need to be heard by listening and by effectively serving women who so often find they have no voice. An important focus of the ministry of Jesus was His way of elevating women just as he did the men who were His followers. He made no distinction among those who sat at His feet, giving women an equal opportunity to learn from Him.

There are five basic misunderstandings held by the Church regarding domestic violence and abuse. They are easily eliminated when candidly reviewed. Scripture reveals much more than what we are often taught.

3 Kroeger, Catherine Clark and Nancy. Nason-Clark. *No Place for Abuse.* Downer's Grove, IL: Intervarsity Press, 2001, p.8

1. *Separation and/or divorce are not an option.* Yes, *God hates divorce **but** more accurately, <u>He hates the violence that leads to a divorce</u>.* Abusive behavior breaks the covenant of marriage. "...and I hate a man's covering himself with violence as well as with his garment..." (Malachi 2:16).

2. *There is no believability if the abuser is carrying out all he should within the Church body or in public. An abuser may look and act like a wonderful person* while behind closed doors he or she is scheming to gain power and control over a spouse or other victim. Generally the perpetrator will have no conviction or remorse and will often even feign affection publically for the victim. It is often very difficult to discern an abuser while in a public arena as his behavior is convincing and his victim does not dare react.

3. *No visible evidence of being hit.* Recognition of the abuser is made even more difficult by the pattern usually followed when battering the victim. *Assault is usually made to the parts of the body that no one sees*; the trunk, the private parts, upper thighs, upper arms, and chest. These can be covered by clothing. Assault is often without witnesses unless that witness is a child. The child is a "safe" witness for the batterer since he will be afraid to tell anyone for fear of further assault on himself or the victim. Even more difficult to *see* is the heart and mind which take the greatest toll, leaving the victim(s) confused and broken in spirit.

4. *We do not make a practice of getting involved because we are not sure of the truth. Determined involvement is essential* to get to the truth and to begin the long road to accountability for the abuser. It takes courage, discernment, education and commitment over a long period of time to break the cycle. Solutions offered can never be quick. Effective involvement seeks long-lasting solutions.

5. *Violence against women is a woman's issue.* There can be no issue in which a person is hurt by another person that is one-sided.

> "If you are a man and you are reading this, you probably agree that violence against women is a significant problem— for women. Few men tell pollsters that 'reducing domestic and sexual violence' is a priority for men. Barring a recent family tragedy, it is unlikely that men would even register these issues as ones we should be concerned with...Most men-and women- see these as 'women's issues.' As I have stated, calling violence against women a 'women's issue' is misleading at best, and is even at some level dishonest. In fact, I think the very act of calling it a 'women's issue' is itself part of the problem."[4]

Katz goes on to list four reasons why calling violence against women a "women's issue" is a problem. Men will then not pay attention to the issues. Men do not think in terms of the women around them that they love; somehow it escapes them that they too might be or might become victims. Men are the primary perpetrators. If women were, Katz postulates that men would not be likely to blame themselves, but the victims for the violence. Men have simply not joined the fight in numbers large enough to make a difference and it may be because of the systematic thinking among the majority of men that this is a "women's issue."

The stories you will read in this book may seem atypical for believers but are too often the "norm" for more women than you would think. Abuse is sometimes responded to by the victim as normal in order to rationalize away the effects. Psychologically this is known as a coping mechanism, a way to survive constant attacks and hide just below the surface of harsh reality. Christian women are particularly adept at this since there are frequently hidden social ladders that must be scaled and domestic violence is not an acceptable "rung."

Celene's story is an example. She could not go through with

4 Katz, Jackson p. 12

breaking her silence. Her greatest fear was that her whole life would change. That was too unfamiliar. No, it was not possible! No one in her Church would believe her deacon husband beat her. Then she found a small bible study of Christian women who did not know her but seemed to want to befriend her. She listened as each one of them shared some personal heartache or triumph. Celene quietly held back her story.

Would they believe the violence she endured? Why she could not stand up to him or leave? Why she could not tell the children? Her answer to her own question was always the same; he was their sole support.

She began to feel accepted. Sadly, no one could know the courage it took for Celene to open up and share. She was petrified at first. Then the words began to form and she slowly began.

Her tears were slow in coming because she was so numb inside. She shared because she was beginning to "feel" again as she drew closer to the Lord. It made her afraid as well. Most in the group were afraid to support her leaving fearing they would be censored by their own pastors. They could not understand that in not supporting they were actually re-victimizing.

Ultimately she withdrew from the group refusing to answer emails or phone calls. The group did know enough about these cases to not contact her. They knew that could be dangerous for her. They could only pray.

Celene had the courage to reach out but enduring the pain and cost of facing the truth finally proved too much. Few in the group knew what kind of advice to give her. Unfortunately most Christians do not know how to give guidance in situations of abuse. One thing was clear; Celene needed to be believed and to give herself permission to go to a safe place.

The home is supposed to be a haven; a place of rest, the place God intended for us to refresh, be nourished and, enjoy one another. A haven to give us strength to face the daily routine, the joys and the tragedies of life. For Celene it was a living hell. It may still be.

Persons who have been abused should receive counseling alone and not with the alleged perpetrator. The condition that both husband and wife be together to receive counsel could lead to further abuse of the victim when once again alone with the abuser. It may also result in a setting in which the victim is not truly believed. *Saving the marriage is not as important as saving the person.* The marriage covenant is broken through abuse. Without repentance, forgiveness and a changed heart, it remains broken.

Asking the wife to forgive her abuser is certainly a godly action; asking her to continue to live with him may lead to further abuse and could even be fatal. The abuser needs to be held accountable for heart change by exhibiting lasting changed behavior.

Let's look for a moment at forgiving the abuser. Jesus taught His disciples to forgive seventy times seven. A profound understanding of why it is necessary to forgive is given by Dr. Dan B. Allender:

> "In response to His outrageous command, they said, 'increase our faith' (Luke 17: 5). The Lord was not impressed by their desire for more faith. He heard their cry for more faith as a means of dodging His words…His position was clear: Even the smallest amount of faith is sufficient to forgive if a person wants to forgive and bear the inherent risks of loving in a fallen world. The issue is never capacity but whether one desires to forgive. I have worked with abused men and women who hear the words of Christ and quit in rage. The law of love is too exacting and unrelenting; therefore, why bother and why try when failure and even greater abuse are the end result?"[5]

Like the disciples, the victims of abuse desire to forgive but are struggling with rage against the abuser for the offense against them or their loved one. As a victim they may also deal with shame and guilt, even seeing themselves as the reason why they have been abused. They may fear that forgiveness is too soft an act against their abuser and that he will never face his sin. They may also fear they will have to continue in the same relationship with their abuser.

5 Allender, Dr. Dan B. and Dr. Tremper Longman III. *Bold Love*. Colorado Springs, Colorado: Navpress, 1994, p. 61

Believers only answer to the command to forgive our enemies. Holding the abuser prisoner in the cage of unforgiveness also closes the victim's heart and causes spiritual death. Help is needed to set safe boundaries in the relationship if one still exists. Setting sensible boundaries is necessary at this point and will serve to assist in making better choices in the future in intimate relationships.

Without forgiveness, the victim cannot be released to go forward with life. As dangerous as it is spiritually not to forgive it is equally dangerous to assume that the abuser has had a heart change and the relationship can continue in a healthy manner.

One of the manipulative skills of an abuser is to feign true change. It is not wise and can perhaps even be fatal to believe the abuser before a quality length of time has passed in which he has been held accountable so proving his change is from the heart.

Trusting even a Christian counselor takes work from both counselee and counselor over a period of time. The victim must be constantly assured that he or she is believed and supported. It requires commitment from the counselor. The steps are painstakingly slow and tedious but the reward is a whole and healthy person alive once more. Even the smallest step is progress and is to be genuinely celebrated.

The effect that the behavior of a perpetrator has on his or her family and on the American society is devastating. Many women are battered while pregnant. According to current statistics from the Bureau of Justice, this is the leading cause of birth defects and infant deaths. Half of battered women report being forcibly raped by their husband. Seventy percent of men who abuse women also abuse their children; eighty-seven percent of children witness the abuse of other members of their family... primarily their mothers. This can be an important factor in a life given to crime.

The United States Department of Justice, Bureau of Justice Standards, states that ninety-five percent of victims of domestic violence are women. *This is why the language in this guide refers to the female*

gender more often than the male. The wife and children of a perpetrator are threatened, coerced, beaten and controlled daily. Children will often fall asleep in school from having spent a night witnessing abuse and disruption in the home, their weary little minds unable to rally. All too often, they have also been a victim.

Women who are victims often cannot hold a job outside the home. Abusers may take their car keys. Or, she may not be able to attend work due to injuries sustained during violent episodes of domestic abuse. Children often run away from home as soon as they are old enough. They fear going to authorities because of what may happen to victims still in the home. School counselors or youth pastors are often the first to know of abuse. Sensitive awareness and careful investigation is necessary to be effective.

Perpetrators will abuse financially by holding control over the money and only allowing certain items to be purchased. They often make the wife or child go to great lengths to get "permission" to buy something. The wife must sometimes keep a certain amount of money in the bank even at the expense of her family or personal needs. She might also be expected to present an itemized list of purchases with receipts that he must approve. Many times she will be forced to return items even though they may be necessary for her or the children. He will berate her for her lack of judgment and make fun of her selections.

The most violent of acts is against the wife or against their children's body. The cherished intimacy of love with a woman is violently disregarded when a wife is raped by her husband or forced into sexual acts that demean or degrade her. This is the epitome of injustice in a marriage. Too often a child is molested by either father or mother, or another member of the family. Usually it is not a stranger but someone known to the child. These are unimaginable acts of abuse.

The perpetrator will often make his wife, or a child, feel they deserve to be violated. The goal is to convince the victim they are worth nothing anyway and have "asked" for the abuse. Victims will

become beaten down and feel as though they themselves have created a circumstance that has rightfully brought on the abuse. There is even the bizarre idea that if the victim takes the abuse, the perpetrator will feel relief and leave them alone for a while. The feeling of worthlessness pervades every area of the victim's life and is very difficult to overcome. Without godly counsel and prayer over a period of time it is impossible to act outside of this deep woundedness. Often counselors will need to plan to spend much time with the counselee to assure healing. Care must be taken that boundaries are kept.

Domestic violence can go unnoticed for a long period of time unless there are signs observed and carefully investigated. Often, signs can go undetected until there is a mental breakdown or death. Excessive depression, unusual body marks, and a high number of hospitalizations for unrelated injuries or illnesses are definite signs that a closer look is warranted. This has to be done with much care to keep the victim from being hurt by the perpetrator if she is questioned.

Fear, anxiety, or nervousness unrelated to a particular incident also needs further investigation. A victim may show signs of discomfort in the presence of others for no apparent reason or be absent from school, the job, or Church for unexplained lengths of time.

Excessive layers of clothing are sometimes worn even when weather does not dictate. This may indicate a desire to be insulated from abuse, a desire to be invisible or, a need to hide injuries. Often the person will become withdrawn and isolated or lose interest in things that previously meant something to them.

Even in the face of domestic violence, women find it difficult to leave. The question that often goes unanswered is, "Why does she stay?" Most often she is unfairly judged by this. A quote from Kroeger and Nason-Clark's book will help to unravel the reasons why. It is not a matter of not being smart enough to leave; it is a matter of fear and intimidation:

"In essence, women remain with the men who abuse them because they are fearful, because they lack the economic or social resources to leave, and because they cling tightly to the hope that someday he will change. In addition, some religious women feel that God does not permit them to leave, that marriage is forever no matter how cruel their husband's treatment, that this may be their cross to bear, or that perpetual forgiveness of their husband for his repeated behavior is God's expectation....The wise pastor will help such a woman navigate these troubled waters."[6]

Two things should be done immediately; pray and listen. Take gentle steps. These wounded women are cautious and will withdraw from even the best intentions when not approached with great sensitivity. Proceed with caution.

As believers, we have been given a grave responsibility to women. Prayer for wisdom and discernment will lead to truth and help. In later chapters, steps are outlined that are helpful when faced with a possible case of abuse. Never fail to enlist the help of authorities if safety is in question. *In a case of a safety concern, you are not bound by confidentiality.*

6 Ibid, Kroeger, p.36

Nadine recalls as she began to tell me her story, that no one had ever believed her. It happened so many times that she stopped telling the truth. He would only beat her again if he knew she had asked for counsel so what was the use? Maybe this time he would kill her, at least her miserable life would be over. It had been going on for so many years that she had become numb to feeling anything again.

The pain was almost a daily expectation and yet here was a chance. This case manager from the shelter actually believed her and was arranging to meet her and bring her to a safe place. She sounded genuine. "Hope is so unfamiliar, desperation is my familiar companion. I am so afraid. What if he finds me?" Nadine remembers crying, "I don't know if I even want to be believed anymore. I don't know how to live any other way now even though I want to be free."

"BECAUSE THE LORD HATH BEEN
WITNESS BETWEEN THEE AND THE WIFE OF
THY YOUTH, AGAINST WHOM THOU HAST
DEALT TREACHEROUSLY…THEREFORE TAKE
HEED TO YOUR SPIRIT, AND LET NONE
DEAL TREACHEROUSLY AGAINST THE
WIFE OF HIS YOUTH"
(MALACHI 2: 14-16).

WHAT IS DOMESTIC VIOLENCE? WHAT ARE THE STATISTICS?

omestic Violence occurs in broken and unbalanced relationships. It may happen as a physical assault such as shoving, pushing, restraining, hitting or kicking. Even if it occurs infrequently, without godly intervention that changes the heart and mind it will escalate.

Though every relationship is different, there are stages of abuse that follow a predictable pattern. The first stage is known as the "tension building" stage when a victim will do everything possible to keep from upsetting her husband or boyfriend. Though her efforts are painstaking, a violent outbreak, the "second stage," usually follows anyway. The "third" stage is the stage when the abuser is remorseful but not truly repentant, saying he is very sorry, and that it will never happen again. A "honeymoon" stage follows that and might last for days or months. Slowly though, the tension will begin to build again and the cycle will continue. Many women admit there is always some level of abuse going on.

Domestic violence rarely happens just once; usually it begins to

happen more and more frequently and more severely with each incident. The term, "Continuum of Abuse," is recognized among those who counsel victims; each type and stage of abuse involves unbearable suffering: Physical abuse can end in death, emotional abuse can end in a person losing her own identity and learning to be helpless, sexual abuse may end in sadism or death.

Sexual assault happens when one partner or person forces sexual acts which are unwanted or are declined by the other person in the relationship. In cases where pornography is being used by the abuser it can become an emotional and mental assault even when it is not physical but verbal and emotional. Use of pornography carries its own kind of terror.

One tactic used in psychological assault is isolation. This is especially effective when there is no transportation but that of the abuser. The victim may be forced to report mileage or gas use. This causes much anguish regarding going to and from anywhere. There may also be financial dependence so that all that is spent is controlled by the abuser. Financial control is another very effective tactic used to isolate. Monitoring phone use is also an avenue to isolate, assault and control.

The abuser may destroy property. Perhaps important papers, pictures and mementos.

Destruction of furniture and even walls and doors is common in fits of rage. Often pets become the first victims and may be abused or even killed during an incident of violence. An abuser will sometimes begin his assault by teasing or threatening a child who may live in the home in an attempt to use that against his spouse. This is a very effective threat and typically gets the abuser whatever he wants.

The prevalence of domestic violence is astounding, affecting men and women alike although ninety to ninety-five percent of victims are women According to the United States Department of Justice Bureau of Justice Statistics. The most recently published statistics state that domestic violence occurs in twenty-eight percent of all

marriages in the United States with rape reported in fifty percent of these cases. In the United States, six million women are battered each year by their partner, one in every twelve to fifteen seconds! How often are these just statistics?

Physical violence is estimated to occur in four to six million relationships each year in America. One in every three adult women experiences at least one physical assault by a partner during adulthood. Out of cases actually solved, thirty-three percent of all women murdered are murdered by an intimate partner. The stranger is a less likely suspect.

Domestic violence affects all races and genders. African American women however, have a much higher rate than other races. It is thirty-five percent higher than that of white females, and about twenty-two times the rate of women of other races. If these women are in urban areas there is an additional increase. Black males experience domestic violence at a rate sixty-two percent higher than that of white males and about twenty-two times the rate of men of other races. It is higher among the poor and disadvantaged.

Domestic violence is the most common cause of serious injury to women accounting for forty percent of all homicides in the United States. Every five years the number of women killed by relatives or acquaintances equals the number of American soldiers killed in the Vietnam War, 54,000! The fastest growing segment of our society is women and children who are fleeing domestic violence and the resulting homelessness.

The cost to Christianity in our society is incalculable; the destruction to the body of Christ cannot be measured. Six million women are battered each year in the United States. It is the leading cause of emergency room visits and hospitalization. Business loss amounts to over one million dollars annually. This is determined by the amount of increased security costs, increased absenteeism, and reduction in productivity, performance, and morale. This figure triples when you include the number of children impacted by

working spouses. Children are too often the silent victims of domestic violence. Sometimes their voice is never heard and they die an untimely death. All too often these deaths may not be reported as being a result of domestic violence or abuse.

The latest statistics from the Department of Justice Bureau of Justice paint a grim picture of the impact of domestic violence from one generation to another:

- Ninety percent of men in jail were abused as a child,

- seventy percent of men who abuse will abuse children,

- seventy-five percent of abused boys have behavior problems,

- abuse of pregnant women is the leading cause of birth defects and infant deaths,

- children under the age of twelve reside in forty-three percent of households where domestic violence occurred and,

- sixty-three percent of all incarcerated juveniles (boys between the ages of eleven and twenty) are there because they protected their mothers.

The highest rates of violence reported is among African-American and Hispanic women at about sixty-five percent; for white women, violence is reported in only fifty percent of documented cases. Fear of reprisal keeps reports down.

When reviewing these statistics there are several considerations as well as methodology that is important in understanding the gravity each depicts. A report by the National Crime Victimization Survey explains that data regarding criminal victimizations is collected from a continuous nationally representative sample of households in the United States. Data is also gathered by the Federal Bureau of Investigation using the Uniform Crime Reporting Program.

Even with the careful federally regulated reporting, all crimes are not recorded. Most crimes involving domestic violence occur

between six at night and six in the morning in the victim's home. This may postpone or hinder proper reporting. The fact that it is in the home is also a notable consideration. Most women and/or children do not want to report the crime out of fear of re-victimization, shame, or ignorance of police involvement or assistance services. This re-emphasizes the need to familiarize yourself and leaders in local police procedures and state law.

It is also worth considering that many types of abuse are not defined as domestic violence by victims who have been living in abusive relationships their whole lives. Children often do not recognize that their home is abusive until they have been exposed to balanced and godly homes. It is sobering.

As noted, forty-three percent of children under the age of twelve reportedly reside in homes where intimate partner violence occurred. For them, the violence is all they have seen. Women too often endure years of abuse before realizing this is not a normal life. Church related counsel too often minimizes the stories told them by women who are hurting thinking that *her* behavior might be the cause.

It is probable that we do not know the whole horrible picture of domestic violence even with the regulation of data. A more accurate picture is given when we choose to see these statistics as underscoring a much more severe problem, an epidemic that exists in America and in the world. An epidemic the Church, the believer, has *the* solution to.

Morgan looked at her face in the mirror. No bruises there. They would show too much! She brushed her long silky hair for the last time, letting its auburn waves fall softly over her bruised shoulders.

Taking scissors in hand she began the cropping. Soon piles of hair stacked around her feet like red mulch. Would this, like the baggy and colorless clothing she had begun to wear make her invisible to him at last? Would it hide the body he so cruelly used for his pleasure?

He preached about being made into the image of God. It made her sick, what perverse mockery! No one in his congregation would ever believe that he was so abusive. She knew the answers they would give; treat him better so he would be happier. Would she ever have real peace?

"YOU HAVE HEALED THE HURT OF THE DAUGHTER OF MY PEOPLE SLIGHTLY, SAYING PEACE, PEACE; WHEN THERE IS NO PEACE" (JEREMIAH 8: 11).

CHAPTER IV

HEARING THE CRY
OF GOD'S HEART

*I*n Psalm 55, the cry of David's heart as he hid from Saul while fearing for his life, is not unlike the cry of women and children who are in hiding whether physically or in their spirit and soul. In Genesis alone, there are several major incidents of domestic violence: Cain is jealous of his brother Abel and murders him (Genesis 4:8), Abram forces Sarah to lie to save his own life (Genesis 12: 12-13), and Jacob tricks his father into giving him Esau's blessing (Genesis 27).

When sin entered the world the plan of satan was to destroy the family. His plan has not changed. The heart-breaking story of Tamar in the book of II Samuel 13: 1-29 tells us that satan used lust to destroy trust in David's family.

Tamar is raped by Amnon, her half-brother. Amnon had desired her until he was beside himself with lust. With the help of a friend he designed a way to lure her into his bed. Amnon made himself sick and when his father David came to see him he said the only thing that would make him well was to have his sister Tamar make cakes and bring them to him. It must have seemed a simple request to David who was unaware that his virgin daughter was being set up for rape.

Tamar cried "no," and asked Amnon not to force her, calling him a

fool. She reminded him that such a thing was not done in their family but he forced her anyway. And then we are told that he hated her.

> "Then he called to his servant… and said, put now this woman out from me, and bolt the door after her …Then his servant brought her out, and bolted the door…And Tamar put ashes on her head, and rent her garments…and laid her hand on her head, and went on crying …so Tamar remained desolate…" (II Samuel 13: 12-30).

Tamar remained desolate. Women today who are victims experience this same shame and desolation. They are rejected by the perpetrator and then by those who judge them.

This is not just an isolated incident. In both the Old and New Testament, incest, adultery, and violence against women and families left women wandering the streets without income and without respect. They often resorted to prostitution just to survive. Sometimes they still do. Unfortunately, current statistics show we continue to be experiencing this tragedy even though many courageous believers and community leaders have fought hard to bring about legal, moral and biblical resolutions. The fight to bring resolution with God's help must go on.

The cry of God's heart has been the same since He sought Adam in the garden, knowing their fellowship was now broken by sin. Or since He called out to Cain who committed the first murder, an act of domestic violence, saying, "What hast thou done? The voice of thy brother's blood crieth up to me from the ground" (Genesis 4: 10), and most assuredly since the blood of His Son spilled for our sin (John 19: 34). His deepest desire was and is and will eternally be to fellowship with each of His children.

God hates the sin that separates His Children from Him and cries out for them. Out of His deep love for all mankind, He made a path that leads back to glorious fellowship with Him (Genesis 3:15).

When Christians are indulgent and self-focused an attempt at fellowship becomes corrupt. This corruption is often expressed through closed eyes and hearts to others who are wounded and broken. Some of those are victims of domestic violence. They may be

as near as the next street over, as close as family. They might be your neighbor, your child's playmate, your friend's husband, or one of thousands who fill the beds of shelters or the streets of America's cities and communities each night. Could it one day be you?

Maybe it is a matter of judging that the place they are in is their own fault. That is not the question. They need a helping hand and acceptance to pull them up from the pit of destruction. It is easy to accept those who we esteem but how difficult, even unpleasant, to accept those who live their lives in desperation, far from our pleasant gardens. In the parable from Luke, Jesus commands to go out and bring them in. "And the lord said unto the servant, Go out into the highways and hedges, and compel them to come in, that my house may be filled" (Luke 14: 23). God's heart's cry and invitation must be given to these women. The challenge is to truly see these women and their needs.

God promises peace and quiet to his people. Listen to Him:

> "And the work of righteousness shall be peace; and the effect of righteousness quietness and assurance for ever. And my people shall dwell in a peaceable habitation, and in sure dwellings, and in quiet resting places" (Isaiah 32: 17-18).

This promise includes all of His children; it includes those living desperate lives within the body of Christ. It includes the stranger who has yet to come in, the victim and, the abuser.

Believers are ministers, possessors of the Holy Spirit residing within to empower, to equip, to change and mold into the image of Jesus Christ. It is a privilege and responsibility to be the hands and feet of Christ Jesus. It does not stop within the doors of the Church; it encompasses the whole globe.

In the last few decades secular leaders have worked together, planning strategies to apply for grants and to seek practical solutions to domestic violence. They have done this because they have seen the destruction domestic violence and abuse brings. They realize it cannot be ignored. It disrupts communities, it attracts more crime, it stunts economic progress and it maims innocent men,

women and children. It is the most prevalent source of breakdown of the American family.

Imagine what an impact there would be if this tragic epidemic were to be wiped out! Is that not the gospel message? With an ear to hear the heart of God, Church leadership *can* also better respond to this epidemic that threatens the family, the very institution the Church is designed to protect. Believers *can* seek practical resources that will not only provide assistance but provide it in the power and compassion of the gospel message. Not only can they but they must! Never has the need for deep Church involvement been greater.

The following Scripture references speak the heart of God for victims affected by the ravages of domestic violence and abuse:

(*Credit for passages and principles below goes to World Evangelical Fellowship, Task Force on Abuse against Women*)

- The Bible calls for loving, responsible relationships between members of the family, with each in honor and industry providing for the needs of the other, (Psalms 128: 1-4; 133: 1-3; I Timothy 5:8).

- A wife is an equal heir of the grace of life and not the possession of her husband, (I Peter: 3:7; I Corinthians 6: 19-20).

- God's plan is that the home should be free of oppression, (Isaiah 54: 5-14; Romans 12:8).

- Physical violence and verbal abuse are forbidden by God, (Psalm 56: 5-6; Isaiah 58: 4-6).

- Silence, denial, secrecy and concealment are not God's way of dealing with problems, (Matthew 10:26, James 5:16).

- The Church is charged with the responsibility to address situations of abuse within its own community. This is not a suggestion, but a command. (Matthew 8:15-17; Galatians 6:1).

- Forgiveness is the work of the Holy Spirit. For the abuser; it must be preceded by true repentance. For the abused, forgiveness

is part of the healing process and will take time and perhaps distance, (I Corinthians 7:10-11; James1:4 and Romans 2:4).

- Sometimes separations are the best course for the safety and peace of family members. It can actually be a tool for reconciliation. (Genesis 13: 7-11; Proverbs 24: 1-2 and Acts 16: 36-40).

- Godly men and women are called to acknowledge the prevalence and severity of abuse, to respond compassionately to those who suffer, and to aid in their healing through practical and spiritual support, (Isaiah 58: 6-7; Romans 12: 15; Ecclesiastes 4:1).

- While Christians may in some circumstances risk their lives for the sake of the gospel, they should not be exhorted to remain or return to life-threatening and/or risk of safety situations, (Romans 16: 3-4; Matthew 4: 5-7, Acts 9: 23-24).

In the following chapters are guidelines on how believers can reach and serve the victims of domestic violence and abuse. There are suggestions on how to build a model Church that has zero tolerance for domestic violence and abuse while exhibiting an ability to minister both to the victim and the abuser. We *can* stop being destroyed for a lack of knowledge (Hosea 4:6), and begin to dig deeper into this dilemma, compassionately bringing hope and healing to our Churches, our communities, and to the world.

The writer of Proverbs states seven things that God hates. He strikingly describes the heart of the abuser:

> "A proud look, a lying tongue, and hands that shed innocent blood, an heart that deviseth wicked imaginations, feet that be swift in running to mischief, a false witness *that* speaketh lies and he that soweth discord among brethren" (Proverbs 5: 17-19).

Let us as believers and as a Church always express *zero tolerance* for abuse of any kind. Let us exercise discernment that alerts us to an abuser and let us never be unprepared to serve the victims. We have an obvious challenge before us as we hear God's heart and it is a challenge we can meet with God's help.

My joy was stolen by a wild wave,
my shame foaming up
pushing me into black darkness,
by those whose hearts were
formed in the same
mother's womb.
 -ews

"MY HEART IS SORE PAINED WITHIN ME:
AND THE TERRORS OF DEATH ARE FALLEN
UPON ME. FEARFULNESS AND TREMBLING
ARE COME UPON ME, AND HORROR
HATH OVERWHELMED ME"
(PSALM 55: 4-5)

CHAPTER V

IN HER OWN WORDS: JEANNE'S STORY

The cycle of abuse began early in my life. I was reared in a preacher's home where God and Church was the most important thing in our lives. My parents were very persistent in teaching me the Word and in living a moral life. I had three brothers and I was the only girl.

When I was around three years old my two older brothers began to abuse me sexually. My parents were unaware of it until my younger brother told after he had walked into an incident. My father spanked me and my older brother; he was seven years older than me. This confused me because I did something that I was forced into. I did not choose to do it. As time passed and my brothers got older the abuse stopped. My life became somewhat easier for a while.

During my teenage years my parents began to have marital problems that escalated. My father began to make comments to me about being fat and lazy and asking me questions like, "Do you want to sleep outside with the dog?" Once when I got three "F's" on my report card, he made the comment that our family dog could do better than me in school. I did not realize that this was not the way a Father should behave. I blamed it on myself.

The sexual abuse I suffered from my brothers together with the verbal abuse from my father created a deep insecurity in me. To make matters worse, my mother was very controlling although she was very

good with keeping up with where I was and who my friends were. I was compliant and had very little misbehavior. At sixteen though, my parents divorced and I began to look for acceptance through my peers. My home structure had been destroyed and at seventeen I became sexually active. Eventually I ran away with a boyfriend of a different race.

On three occasions I was raped. I believe I presented the picture of an easy victim as my self-esteem was low as a result of prior abuse. After two years of going back and forth between my Mom and my brothers and my Dad, I eloped and married a boyfriend of whom my parents did not approve.

I tried to have a life with the boy I had married but he had no respect for me and I had no respect for myself. During those two years, I slept in cars, went for days without food while pregnant, and continued in the cycle of confusion and inconsistency. I did not feel like a real person; I did not know who I was.

Once, on a Christmas Eve, the Salvation Army put me and my husband up in a hotel. We only had two dollars together. My husband decided to buy a beer and showed no conviction that I had not eaten all day. I got complimentary popcorn from the lobby and that was not even the worse of days.

I can recall occasions where I walked out of restaurants after eating because there was no money. My husband would excuse himself to go to the car first and then I would just walk out.

Once he snuck me into the men's barracks at his army post to have a place of safety to sleep. I called home to my mother to send for me and she told me, "If he doesn't take care of you now, he never will." I can remember calling my father while he was just a couple of hours away visiting family. He did not come. No one heard my cry.

Finally I talked my husband into taking me home. He had to go A.W.O.L. to do so. I stayed with friends and eventually found an apartment. I had my first child at the same time my husband was dishonorably discharged from the military. He moved into the apartment but it was only two months before we were behind in bills. When there was money he spent it on drinking and partying while I was taking care of our newborn son.

Later, after my husband left one night to go to a party, my mother allowed me to come to her apartment. She told me I had three months to find a place to live. I had no one else I felt comfortable turning to.

My home Church had been the place my father had to resign from after having an affair that resulted in divorce. I also felt like the Church knew about the disapproval my parents had for the relationship I was in. I could no longer feel at home there, I only felt judged.

While still living with my mother I learned I was pregnant again. My first born son was only eleven weeks old and I was now five weeks pregnant. I did not know what to do.

A neighbor across from the apartment we were in was a single mom in nursing school. She introduced me to a friend of hers who knew about Hannah homes and gave me their number. I called and spoke with the director who conducted a phone interview and I was accepted. It was good and bad, I was glad to have a place to go and yet very sad.

When I arrived I was in a state of complete brokenness. It was beyond my comprehension to find myself in a place with all kinds of women I had never been exposed to. I looked around and there were drug addicts, prostitutes, battered and abused women, and women who were homeless and in hard situations I never knew existed. I was terrified.

So here I was with my baby and one suitcase with only a pretty Church background, or so it seemed. I settled in my room and cried myself to sleep only to be awakened by the dinner bell.

I learned a lot living the "shelter" life in the two years I was there as a resident. I began to feel secure for the first time in my life. I knew the children and I would have a place to eat and sleep. I also learned that all people from all walks of life were just like me and needed love and family. They became my family. I no longer felt like an outsider.

I successfully completed the program and moved out on my own. I have returned from time to time over the years to share my story with others giving them hope in the face of despair. This is real life today. I am so happy I found that we are all equal and that with God, *all things are possible* (Luke 1:47).

Sherry walked with a slight limp for several days, holding her arm close to her side so no one would notice the bruises. Makeup concealer hid the scratches. Who would believe her? Her husband was an associate pastor and liked by everyone. She felt bound to obey him. She said she just needed to be smarter and stay out of his way and keep peace when he was home.

"The children never got much positive attention from him. He said they were too little and he just didn't know what to do with them. They love him but he can't see it. I need him but now I am filled with hatred and bitterness most of the time.

Maybe I really am unfit. I know I can't keep the house as clean as it should be and I am not really good at being the perfect hostess. He always yells at me the minute people leave and reminds me of how stupid I am. Maybe I am. I can't make ends meet and I can't keep the kids quiet. It would have been better if I had not been born. That's what he tells me when he is angry. I am keeping him from moving up in his Church. It was always about him."

"FOR WHERE ENVYING AND STRIFE IS THERE IS CONFUSION AND EVERY EVIL WORK" (JAMES 3:16).

CHAPTER VI

RECOGNIZING AN ABUSER

*T*he information given in this guidebook should not be considered exhaustive but it *will* give you important basic knowledge that can be expanded by further research. Abusers are insecure and needy people. They *can* change their behavior by allowing God to heal their hearts and renew their minds. They have to acknowledge their sin, repent, and be held accountable.

From the experience of working with victims over twenty years, it is the writer's opinion that domestic violence and abuse is behavior that is most often learned in the home. Since it stems from the need to have power and control, it often occurs when the abuser is threatened by the spouse or from another individual in the home.

If there is a difference in prestige or position whether economically, in a community, work, or Church setting, abuse may follow. When a job or position fails for the abuser he may resort to violence in the home to release the tension he feels against others. He may also project that the spouse or children are to blame for the failure since he cannot face the failure himself.

There are definite signs to watch for that may indicate that a person is an abuser. (Credit for the following goes to Dr. Violeta

Olmoguez for information given on this subject in her book "Pastor's Handbook on Domestic Violence").

1. If the abuser is a Christian, he may take Scripture out of context or twist verses to justify his behavior. "The Bible says I am the head of the house and you have to submit to me."

2. Holds others to high expectations and loses his temper at the least sign of his expectations not being met.

3. Tries to elicit the sympathy of others by manipulating the real circumstances of the abuse. "You should have been there to see her falling down the steps. She just couldn't get her legs under her. It was hilarious wasn't it honey?"

4. Blames the victim, privately and publically shaming her. "If she had gotten a decent education she would have been able to answer that question."

5. Bends rules for themselves but not for others.

6. Is rigid and legalistic but describes it as "old fashioned."

7. Usually dislikes women and believes they are incapable of possessing intellect and understanding.

8. Generally jealous and possessive, quickly blaming the victim for anything that solicits attention from anyone. "You think I didn't see how you acted? You made him think you were interested in him by being so nice."

9. Humiliates and belittles the victim, inventing things to make her think she is going crazy (such as hiding her keys and calling her stupid for losing them or turning the stove off if she is cooking then saying she can't be trusted).

10. Will not control his anger or emotional and sexual impulses.

11. Portrays himself as an out-going and likable person to others. Goes out of his way to help other people but not her.

12. Uses guilt to control the victim. "You would do this if you really loved me."

13. Very closed-mind, demanding.

14. Believes in the stereotype masculine role of male supremacy.

15. Controls the finances and other decisions.

16. Isolates the spouse and/or children from others.

17. Verbal abuse is common. "How could you do something so stupid?"

One of the signs of abuse that is not mentioned above is intimidation. This is a common tool used to exercise power and control. Often it is after a couple has been dating a while or, after they have been married, that intimidation or bullying begins to manifest. For a while everything seems perfect then suddenly he says, "What did you do to your hair tonight, I don't really like it that way." Later it may be that he does not like the way you walk, or the way you chew your food.

The victim will not often recognize the subtle coercion when it comes in small doses. What is more likely is that she will try to correct areas that are pointed out in order to please her abuser. Victims of domestic abuse just do not see the pattern at first, if ever. They often do not realize they are victims until they begin to experience a violent outburst of temper or physical violence. Even sexual abuse can begin in a rather innocuous way. Later, it becomes a path of the worst violence against a woman, raping her soul as well as her body.

The oppression of intimidation may be as mild as a seemingly harmless remark about how she did not look as nice as she has in the past when they went out to dinner. That is confusing because he captured the fact that at one time she looked nice and so she does not feel quite so bad; she determines to really look great the next time. And so it begins. It is an endless game that never stops and no one wins. She will never please him.

In addition, intimidation can quickly lead to violence. A witty remark can lead to a physical strangle-hold catching the victim off guard. In the beginning this ends with, "I was just kidding." Later it becomes, "You don't want me to hurt you do you?" and the hold becomes a serious injury.

Abusers can manipulate their way back into a broken heart by promising to change and flooding the victim with flowers, gifts and apologies. She wants so much to believe. When she does, the cycle begins again. First is the "honeymoon" stage, then the tension builds followed by threats and intimidation, and then comes the violence. He is sorry. She forgives and it begins again. It is too often true that if "nothing changes, *nothing changes.*"

Though the cycle repeats itself, it may not be in this order. It is, sadly, very predictable but it often becomes harder to distinguish one cycle from the other as the abuser continues his battering.

Three to four million women every year, one every fifteen seconds, are battered or abused either verbally, psychologically, sexually, or physically by someone they know. *Is that person in your congregation? Is that person in your community? Is that person your neighbor or co-worker?*

Sara had spent too much time that morning getting ready for school and was late for class, an unusual slip for her. It did not matter; Chuck was going to meet her in the gym right after lunch. She still felt flushed with excitement when she thought about him; she was not even a popular girl and he was suddenly interested!

Sara met Chuck but she did not return to class. She had been totally wrong about him and was now devastated. He thought his popularity would melt her defenses and had tried to force her to have sex; somehow she managed to get free. As she ran home she realized what a mess she was, her hair was undone, her blouse was torn, and she had scratches and bruises.

He said he would make her pay. Dear God, what does that mean? Fear began to choke her. How could she be safe now? No one would ever believe this about Chuck but they would believe whatever he told about her.

"BECAUSE OF THE VOICE OF THE ENEMY,
BECAUSE OF THE OPPRESSION OF THE
WICKED: FOR THEY CAST INIQUITY UPON ME,
AND IN WRATH THEY HATE ME"
(PSALM 55: 3).

CHAPTER VII
TEEN DATING AND ABUSE

*D*ating in the United States can carry its own special brand of abuse. Films, books, television shows and magazines paint pictures of a powerful and apparently desirable attraction to the opposite sex as early as elementary years. Many parents mistakenly expect it to have no negative affect on their youth however, without strong guidance and support during the teen years, many youth will have the worst experiences of their lives in the world of dating and relationships with the opposite sex.

It is extremely likely that you or someone you know has experienced dating violence in a relationship. Violence can be in the form of psychological, emotional, physical, or sexual abuse. It may be in the form of insults, threats, swearing, or humiliation. Physical abuse may include behavior such as: Hitting, slapping, hair pulling, kicking, biting, shoving, and punching. Recently a local newspaper told of a pre-teen who was held down against her will by a gang of younger boys and kissed over and over until she somehow wriggled free and ran.

"Both boys and girls report being physically violent in relationships. Typically however, teenage boys and teenage girls use physical force for different reasons and with different

results. While both tend to report acting violently because they were angry, teenage boys are much more likely to use force in order to control their girlfriends, while girls more often act violently in self- defense…boys often say… that they found the violence amusing"[7]

Sexual abuse will include forced or unwanted sexual activity, engaging in sex through coercion or, after forcing drug use. When there is forced drug use the victim is sometimes unable to recall what really happened and is therefore, confused and guilt-ridden.

According to recent statistics, one in eleven high-school students had been hit, slapped, or physically hurt on purpose by their boyfriend or girlfriend. These same students reported having been forced into sexual intercourse unwillingly. For many, they are simply repeating behavior they have seen at home. If parents are immature, children will likely be also.

At least ninety-six percent report emotional and psychological abuse in their dating relationship. Teenage girls are much more likely to suffer from sexual abuse than teenage boys.

As with adults whom you suspect may be involved in a violent relationship, pray and ask questions. Ask if they are feeling uncomfortable or tense or even afraid in the relationship. You may even say, "You don't seem as happy as usual." Ask, "Is there something you want to talk about?"

Help them to trust their feelings and make the decision to stop seeing this person. Let them know the abuse only gets worse and they can never "fix" this person.

Teen dating violence follows the same patterns as adult abuse. There is the tension-building followed by the violent outburst and then the period of remorse. For a time all will be well (honeymoon stage) and then it will begin again. Choose to help the teenager and open up communication with him or her now. It takes unconditional love.

7 http://www.safeyouth.org/scripts/teens/dating.asp

Getting youth involved in Church activities where character and integrity is emphasized and abstinence is an expected standard is paramount. Negative peer pressure is a very real factor in breaking down discipline or natural barriers the youth may have in place.

Letting youth know that being sexually active is neither normal nor an expectation at their age can be better supported in a culture where that is emphasized. Churches *can and do* provide that culture. When they do not come from a home environment where parents have a healthy relationship themselves, teenagers are easily influenced to make decisions that can produce long-term damage to themselves or others. They need to believe in themselves and to know how much God loves them. They need to be taught that they are the "apple of God's eye" (Deuteronomy 32:10). They do not know what lovely and interesting persons God has created them to be.

Youth in crisis, need to know there are safe places to get help. The Church should always be a safe place to get counsel however; youth may be embarrassed or just simply not know how to ask. Leadership can make it easy by placing pamphlets out that give guidelines on relationship behaviors and right expectations. They can point the way to certain counselors who will help in a confidential manner through certain logos, labels, or phone numbers.

Churches and communities can develop a culture that says abuse in any relationship is not tolerated. Teens need to know there is a place, either a Church office or school or local business where they can go in a crisis. "Safe Place" is an organization that can develop this for you. Most teens hear about them from school presentations.

Though in most states it is the law that family members or guardians are called to let them know their youth is safe, this organization goes on to set up a plan to protect the youth and help the family through a difficult time or crisis. Local Churches can easily be part of the plan to help these families by working within communities to see that they set up these agencies. They can also

develop a plan within their Church to provide "safe places." This youth may need a haven and is not ready for a "group."

When a youth in crisis walks into a designated <u>Safe Place</u> (identified by a sign or decal), they can tell the first available staff person that they need Safe Place help. The staff person then finds them a comfortable place to wait while they contact the local Safe Place or a local Church staff member who can give them confidential assistance.

Within a short time a trained <u>Safe Place</u> counselor or Church staff counselor will come and begin working with the youth. Sometimes it is necessary to transport the youth to an agency for counseling, support, or a place to stay until the crisis begins to be resolved. Collaborating with local police and child care agencies is an important part of pre-planning when dealing with youth. It is *not* always the best and safest thing to do to return them to their parents. This may bring further abuse. A Safe Place agency, local police, or the county Child Care Agency or Church will determine when it is safe to contact the parents and how that will be done.

This is an opportunity for Churches to reach youth and families in need. Statistics taken by National Safe Place show that 65,992 youth received help at Safe Place sites as of May, 2003. There were at that time almost 14,000 sites available across the country in forty-two states. Over 62,000 youth had received counsel by phone as a result of the efforts of Safe Place agencies. It is one thing churches and community agencies and businesses can do to make sure youth know there is a safe place to find help. It is a critical need in our society and in the world today.

> "Communities all share a concern about the safety and welfare of their youth and search for ways to keep their young people safe. Project Safe Place is a program designed to provide access to immediate help and safety to young people at risk of abuse, neglect and/or other serious family problems...

Businesses, community buildings and buses are designated as Safe Place sites and prominently display a distinctive yellow and black Safe Place logo. Any youth can walk into a Safe Place and let an employee provide the help they need."[8]

I watched them unloading out of the big white vans, purses slipping down over bare arms in forty degree weather, others wearing oversized coats. Their kids were scrambling out of the van, many in outfits too small or too large. Mothers with missing or broken teeth, their too tight jeans alluding to a more decadent lifestyle than that of worship. Still they filed into pews, too closely packed to look at all comfortable. They all seemed nervous, a few sang, a few shed silent tears. As we left two of the smallest boys ask excitedly "can we come back?" I knelt down and hugged them knowing they would have trouble fitting in. "You bet," I smiled. My heart knew that only Jesus welcomes all.

"… HE JUDGED THE CAUSE OF THE POOR AND NEEDY; THEN IT WAS WELL WITH HIM: WAS THIS NOT TO KNOW ME? SAITH THE LORD" (JEREMIAH 22: 16).

CHAPTER VIII

SERVING VICTIMS EFFECTIVELY

Knowing God cannot happen apart from serving God. This is the heart of a true believer whether he or she serves in a Church, mission or community setting. According to the prophet Jeremiah, when the cause of people is handled with judgment and justice, then things go well. Serving our neighbors when and where we find them in distress brings us closer to knowing the heart of God.

Effective servants must first have a heart to serve God, doing so in worship *of* Him and fellowship *with* Him. That relationship with God is the foundation that allows Churches to start being more effective in all areas of ministry.

Effective Church outreach must include separate programs for abuse victims *and* their abusers. Letting victims know that the Church holds zero tolerance for abuse of any kind is the best place to start. God is a God of action, calling the Church to step out of a place of silence and denial into a place of openness. He calls and equips and empowers.

Biblical solutions must be applied to the scourge that tears at the very fiber of the family. The heart of God is to protect the foundation of the family, the institution He created when man and woman

began to walk upon the earth. The plan of satan is to utterly destroy this institution. Silence or denial of the issues of domestic violence and abuse is the vacuum in which satan's destruction gains ground.

Individual believers and Churches *can* choose to become models of achievement in the fight against domestic violence and abuse, leading the way to bring hope to victims with the gospel of Jesus Christ. Here are four suggested steps on how this can be done:

I. Repent of the neglect of victims and ask God to empower with the Holy Spirit as changes are made.

 A. Believe the victim.

 B. Treat them as we would want to be treated.

 C. Hold abusers accountable by effectively applying Church discipline. (See Help for the Abuser).

 D. Offer consistent counsel through unconditional love for the victim and the abuser separately.

 E. Offer to assist confidentially in finding safety and resources.

II. Seek education for the Church and community on the subject of domestic violence and abuse.

 A. Set aside a day to focus on domestic violence and abuse. Invite local shelter directors to share from their heart.

 B. Obtain materials on the subject of abuse. Print small cards with safety plans that can be easily picked up in your Church or in community locations.

 C. Develop educational videos for small groups and leadership to explore this subject. Teach youth and adults what a healthy and godly relationship is. Educate teens on dating abuse.

D. Teach biblical conflict resolution, not just as it pertains to marriage and family but to youth, young adults and children.

E. Develop workable, cooperative relationships with local law enforcement. Have them come and outline steps victims must take when police must be called.

F. Train your counselors in the subject of domestic violence and abuse and in state laws that govern abuse.

III. Develop a program to provide for the immediate safety and basic needs of the victim(s). A safety plan is vital for her.

A. Know where your local shelters are and be familiar with their process of intake and their locations. It may not be safe for you to transport; get advice.

B. Develop resources such as food, clothing, and funding for immediate needs to be met.

C. Develop a team of crisis counselors or, be in partnership with a local service to obtain crisis counseling in the areas of domestic violence and abuse. The addition of a Hotline in your area would be a great resource.

D. Plan to begin a job opportunity program to assess skill level, train new skills and seek employment for victims.

E. Be aware of how to provide connections to government housing and other assistance. There are state and federal web-sites that can assist in this.

IV. Connect with local domestic violence shelters and community services.

A. Identify shelters and services. Invite them to become part-
 ners in stopping domestic violence by applying biblical
 solutions.

B. Support local shelters financially and practically through
 funding and mission projects.

C. Develop a volunteer program to help in local shelters.

D. Partner with local shelters to provide supplies for their daily
 operations: laundry detergent, household cleaning, per-
 sonal, and office supplies are always in short supply.

E. Provide a place for local support groups to hold meetings to
 educate and support victims or those struggling with abuse.

F. Provide education about domestic violence and abuse when
 conducting pre-marital counseling.

G. Provide safe places for youth to come for confidential coun-
 sel. Train leaders to handle this counsel wisely and safely.

H. Hold a forum on domestic violence and abuse to train
 people in understanding the issues. Many who are victims
 will attend a meeting such as this to test and see if someone
 would really listen and believe their story.

I. Commit to the highest standard of confidentiality and care
 for victims.

In essence, prepare to present hope to those who have been
silent among you about the abuse they may be enduring or, to those
who do not feel safe to bring their problems to you. Be prepared to
open your doors to those outside your walls who are not receiving
the gospel of hope because they do not attend your services or any
services at all. Be prepared to present hope to people who may be
very much like you but, are hiding behind a mask of religion. Be
prepared to carry Christ to someone you would never see unless you

reach out into the highways and hedges to victims hiding there. Be prepared not to judge but to *see* with the eyes of Jesus.

> "In a social climate where women who report sexual and domestic violence are often disbelieved and called 'accusers,' it is crucial that men personally and publicly support survivors- girls and boys, women and men. This can mean the offer of a supportive ear in a conversation, or a shoulder for a friend to cry on. It can also mean challenging others-men and women- who seek to discredit victims' accounts of their victimization."[9]

Taking these steps is risky but, not nearly as risky as not taking them is for those you could have helped and did not. *The issues surrounding domestic violence and abuse will not go away if ignored.*

9 Jackson, Katz. *The Macho Paradox*. Naperville, IL: Sourcebooks, Inc., 2006. p. 260

Trianda knew something wasn't right about her boyfriend's behavior but she couldn't put her finger on it. His cutting remarks were getting to be hurtful. He was acting as though he owned her and now he was pressuring her to have sex.

Suddenly she realized that his attitude was just like her Dad's had been with her mama, "Dad did not respect mama; she never got respected, just beaten down." Trianda realized that she needed to stop the relationship but she really needed to talk with someone. She knew she was already afraid and that he could physically overpower her. Who could she turn to?

"FOR BY WISE COUNSEL THOU SHALT
MAKE THY WAR; AND BY A MULTITUDE OF
COUNSELLORS THERE IS SAFETY"
(PROVERBS 24: 6).

CHAPTER IX

IS THIS RELATIONSHIP ABUSIVE?

*I*t is very difficult to get a person you think might be a victim to actually acknowledge that she is. She is already confused, afraid, embarrassed, and feeling powerless. Her trust has been broken. It will be hard for her to trust you. That is why continuing to befriend a possible victim and staying in an open relationship with them is extremely important.

Abusers will try to manipulate their dating partners; husbands will try to manipulate their wives and/or children by making all of the decisions, putting them down in front of others, threatening to kill themselves, stalking them, or forcing them to have sex.

The following signs can be indicators for the discerning person:

- Are there bruises, scratches or injuries that are unexplained?

- Does she seem afraid of her husband, boyfriend?

- Does she seem to be controlled by his demands, does he check on her constantly, demand to know where she has been and with whom, act jealous or possessive?

- Does he lash out at, criticize or insult her?

- Does she minimize or deny his behavior; does she apologize for it or make excuses?

- Does she casually mention his abusive behavior as though it is a joke?

- Does she seem to be giving up hobbies or activities that were once important to her?

- Has her appearance or behavior or moods changed recently?

- Does she appear unhappy or depressed more than before?

- Is she anxious, jumpy, nervous, does she cry easily, is she secretive? Does she avoid eye contact?

- Has she started drinking or using drugs?

- Has her health suddenly declined?

- Does she go to the doctor or ER more often?

- Does she have to account for her money, use of the car, or use of credit cards?

- If she has children, are they more anxious than usual? More depressed? Too sleepy during the day? Having academic and / or behavior problems? Do they seem fearful?

If you are able to ask these questions and there are two or more "yes" answers, the person could be in an abusive relationship. You can help by encouraging godly counsel through a trained Church counselor or with a local Crisis Center. Go with her if necessary.

Help her plan for safety in her home or workplace while she is out. Safety planning is an important and vital step when in an abusive relationship. The planning of how to stay or how to leave may be what saves the life of the victim and of her children. The National Domestic Hotline provides steps to help in the planning. Following them is not a guarantee but, it could help to improve the

situation. This guide includes a safety plan to follow; it will need to be kept hidden from the abuser.

Keep in mind that many victims try to leave *at least seven times* before they actually carry it out completely. Also, keep in mind that many women are *killed after they leave.* It is imperative that the victim plan to be in a safe place for as long as is prudent.

There comes a cry that slowly dissolves
into a whispered whimper,
There comes a pounding of feet
stumbling to a deadly halt.
There comes a beating heart that wildly wonders if dreadful
fear will always rule her heart.
There comes a silent prayer formed with
bleeding and swollen lips;
trapped, hurt, aching, crying, dying;
Oh Lord, have mercy,
have mercy.

-ews

THOU HAST SEEN IT; FOR THOU BEHOLDEST
MISCHIEF AND SPITE, TO REQUITE IT WITH
THY HAND; THE POOR COMMITTETH HIMSELF
UNTO THEE; THOU ART THE HELPER OF THE
FATHERLESS…THOU HAST HEARD THE DESIRE
OF THE HUMBLE: THOU WILT PREPARE THEIR
HEART, THOU WILT CAUSE THINE EAR TO
HEAR: TO JUDGE THE FATHERLESS AND THE
OPPRESSED, THAT THE MAN OF EARTH MAY
NO MORE OPPRESS"
(PSALMS 10: 14 AND 17-18.)

CHAPTER X

HELPING A PERSON STAY
HELPING A PERSON LEAVE.

*B*y following the information that has been given in earlier chapters, you may help the person recognize that the relationship is abusive. This is often the hardest step for the abused; denial is the first line of defense. Let the person know you have seen the abuse and want to help. Lead them to understand that the behavior being experienced is not "normal." Reassure the person that they are not alone but have your support and the support of many others within the Church and the surrounding community.

It cannot be emphasized too much that you should listen and believe what you are being told. Usually what you are hearing is only the tip of the iceberg.

Often, even in the telling the victim will try to temper the real depth of violence and abuse that she has endured. It takes a lot of courage to tell anyone about abuse when you have lived so long in its shadow. A major step toward freedom for the victim is being believed. If the person senses that he or she is not being believed an immediate sense of rejection begins to descend. The victim shuts down once more.

If the person is not ready to take any steps to change or end the relationship, remain non-judgmental and offer to continue to listen. You cannot rescue this person even though you may care deeply for her welfare. *She* must ultimately decide and you must allow for that. You can only be a listener, a comforter, and a guidepost to peace with God.

Encourage the person to participate in outside activities. This is often difficult but, when achieved, it births a sense of confidence and allows for new insight into her situation. Fun and laughter will shed new light in her dark world and begin to clear her thinking. It also promotes good health.

There are four important goals that Christians helping victims of domestic violence and abuse must keep in their mind while they lend support or advice.

These goals will make a major difference in whether or not you will penetrate the heart and build trust.

1. *Safety* is the first goal for the woman and her children.

2. *Accountability* is the goal for the abuser.

3. *Restoration* is the next goal *when possible.*

4. When restoration is not possible there must be a time for *grieving* over the loss of the relationship.

Educate her on the risks of staying and the risks of leaving the relationship for her and her children. Give her information about local shelters, about police involvement, and about local hospital and clinics that will help her if there is an emergency. The best help is to get her spiritually and practically prepared to face any eventuality. Gently feed her the Word.

The following summary of possible risks for staying in or leaving an abusive relationship is taken in part from an analysis done

by the Greater Hartford Legal Aid, Inc. in September of 2000 and posted on the NDVH website @ http://www.ndvh.org. These possible outcomes can create further setbacks for the victim but must be considered.

IF SHE STAYS THERE MAY BE:

- Threat or injury to herself, her family or friends.

- Loss of family or friends support if they disagree with her decision or if he isolates her from them.

- Loss of relationship through further deterioration or injury or death.

- She could be arrested if he turns her in even for something she did not do or did not participate in willingly, such as a crime.

- Loss of residency status.

- Loss of job.

- Physical/ psychological injury to children.

- Loss or damage to property or possessions.

- Loss or damage to pets.

- Standard of living might change if he withholds money or does not meet her fiscal needs.

- She may contract an STD or HIV if his sexual boundaries are unsafe.

- She may be subject to possible long-termed effects of his assaults.

- She may become dependent on alcohol or drugs to cope with the pain emotionally and physically.

- She, or the abuser, may commit suicide as the relationship becomes unbearable and all hope is lost. Watch carefully for signs that either the victim or the abuser may be planning to take his or her life and get help for them immediately from Church or a crisis counselor.

IF SHE LEAVES SHE MAY BE SUBJECT TO:

- Threats of injury to family or friends that are sometimes carried out at this stage. *Most women are killed after they leave an abusive partner.*

- Loss of support from family, friends and even the Church often happens in the midst of misunderstanding.

- He may threaten to turn her in if she has participated in any criminal activity even if she was forced to do so. She may try to defend herself against him and end up being charged with a crime. This could lead to jail time, loss of job, children, and public embarrassment.

- She could lose her home, her main source of income and other benefits.

- She would be alone; she would become a single parent.

- She may become hopeless and turn to drugs or alcohol or contemplate and even attempt or carry out suicide.

These possibilities can all be greatly lessened when there is accountability for the victim *and* the abuser. Planning for safety whether in or out of an abusive relationship will also decrease the risks. Whether the victim goes or stays she *must* be supported. The act of staying or going is only a step on the path to wholeness. The path is long and difficult and many times there are set-backs.

Sometimes a woman returns to her abuser. This is *her* choice. She may return because her mind cannot grasp the unfamiliar state of not having this person around even though he was abusing. Sometimes it is the acute strangeness of the new and unfamiliar surroundings of a shelter; sometimes it is the love she still feels for the person the abuser once was or who she thought he once was. Sometimes it is the lack of acceptance outside of the home setting. There is a lot of stigma associated with violence and abuse.

It can be because of the criticism or lack of understanding of people with good intentions. It can be the poor and misguided advice of Christians who place the continuity of the marriage ahead of the survival of the victim. Sometimes women just can't make it financially. Sometimes it is because the children cry for home.

In Anna Kosof's book, "Battered Women", she discusses how women who stay with their abusers are as misunderstood and criticized as those who leave. She cites a common myth that women really enjoy being abused. It is beyond the pale of understanding why this preposterous myth would be believed,

> "Another common myth is that the women stay because they like being beaten and abused, In fact, women do not leave the abuser because it is very difficult to escape...The myth that the women provoke the men, that they 'deserve' to be hit and beaten, that they are responsible for pushing the

> abuser past his breaking point, is one misconception that
> we need to explore and then quickly dismiss. This assumes
> that men need not take responsibility for their own actions,
> an assumption that is false and dangerous. Men, as well as
> women are responsible for their own actions."[10]

This is where a good and balanced Christian friend or coun-
selor can gently bring the person to reason and godly guidance. It is
important to *Remember not to take unnecessary risks yourself.* Keep
you and your family safe from the abuser as well by not reveal-
ing your home address, your home phone, or your facebook or
email address. Keep information about your family at a mini-
mum. For example, meetings are safer in a public place such as the
Church office (during daytime or service hours only). Calls can be
made from the Church phone as the ID will raise fewer questions
from the abuser. Set up a plan for the person to contact local law
enforcement or paramedics when help is needed rather than you
personally. Once she is safe, ask her to call from there and let you
know she is safe.

There are other risks associated with helping the victim. It is crit-
ical that you do not allow the person being abused to see you as her
rescuer. *Jesus is her Savior, not you.* It feels good to be needed but do
not confuse that with your own personal needs. One of the greatest
risks of being a helper is the emotionally charged issues that involve
matters of the heart. It is very easy to confuse your desire to help
with your own issues or to become involved sexually with a victim
and/or emotionally attached. Remember, she is already wounded
and only knows how to act in the role of a victim. She has issues of
her own to face. Take care of yours elsewhere.

If you feel yourself becoming involved in any way that leaves you
disturbed, check your heart. *Make sure you have regular conversations
with your pastor or an accountability partner.* The subtle luring of the

10 Kossop, Anne. *Battered Women (Living with the Enemy).* Danbury, CT. Franklin
Watts, A Division of Grolier Publishing, 1994.

enemy is often best detected by balanced and trusted Believers not involved in counseling or helping the victim. This allows for a discerning spirit and a fair perspective for you.

Jim confessed to the prison chaplain:

"*I was drowning in my sin. I knew my fits of anger and violence were getting worse and coming more often. I didn't know what to do. I was able to hide the alcohol for so long and then it began to control me. I was so ashamed of my behavior each time and Betty always forgave me. I didn't mean to hurt her. Will God ever forgive me?*"

"IF WE CONFESS OUR SINS, HE IS FAITHFUL AND JUST TO FORGIVE US OUR SINS, AND TO CLEANSE US FROM ALL UNRIGHTEOUSNESS" (1 JOHN 1:9).

HELP FOR THE ABUSER

*I*t is important to know how to help the abuser. The FAITH-TRUST Institute of Seattle, Washington, gives the following guidelines for Christians helping an abuser:

- "If the abuser has been arrested, do approach him and express concern and support for him to be accountable and to deal with his violence.

- Do not meet with him alone and in private. Meet in a public place or in the Church with several other people around.

- Do not approach him or let him know that you know about his violence unless, a) you have the victim's permission, b) she is aware that you plan to talk to him and, c) you are certain that she is safely separated from him.

- Do address any religious rationalizations he may offer or questions he may have.

- Do not allow him to use religious excuses for his behavior.

- Do name the violence as *his* problem, not hers. Tell him that only he can stop it; and you are willing to help.

- Do refer to a program which specifically addresses abuse.

- Do assess him for suicide or threats of homicide. Do warn the victim if he makes specific threats towards her.

- Do not pursue couples' counseling with him and his partner if you are aware that there is abuse or violence in the relationship.

- *Do not go to him to confirm the victim's story!*

- Do not give him any information about his partner or her whereabouts.

- Do not be taken in by his minimizations, denial or lying about his violence.

- Do not be taken in by his "conversion" experience. If it is genuine, it will be a tremendous resource as he proceeds with accountability. If it is phony, it is only another way to manipulate you and the system and maintain control of the process to avoid accountability.

- Do not advocate to the abuser to avoid the legal consequences of his violence.

- Do not forgive an abuser quickly and easily. Accountability is critical.

- Do not confuse his remorse with true repentance.

- Do not send him home with just a prayer. Give him assignments to complete and work with others in the community to hold him accountable.

- Do pray with him. Ask God to help him stop his violence. Repent and find a new way.

- Do find ways to collaborate with community agencies and law enforcement to hold him accountable."[11]

Much prayer and gentle admonishment is necessary during this stage. He needs a strong hand to guide him. He will fail and helping him can become messy. Have patience. He did not get this way overnight and a "quick fix" is likely not to have long-lasting effects.

Do disciple him. Be very careful to listen to the instructions of the Holy Spirit. It is tempting to promise reconciliation of the marriage when that may not happen. Promise the abuser that God's Word is sure and that he will grow into a place of perfect peace by following it.

11 THE FAITHTRUST INSTITUTE:
Responding to Domestic Violence: Guidelines for
Pastors, Rabbis, Imams, Priests and Other
Religious Leaders. Seattle, Washington:
http//www.faithtrustinstitute.org

Open my eyes that I may see...
Do I Really See This Woman?
Lord, open my eyes,
remove the blinding veil of complacency, give
insight to my heart, my spirit.
If I look away from her,
forgive me and redirect my vision.
When my steps follow my own feelings and I walk on the other side of
her road, stop me, forgive me.
Redirect my steps as You have promised.
When I must choose between my own want and her need, prompt me to
quickly choose to help.
Teach me the sacrifice of true love Lord.
I judge too easily, I form opinions too freely;
I am sometimes ruled by "religion" and really do not seek to know her
heart as God knows it.
Only You, Lord, know why she is in crisis.
How cleverly I forget my own crisis and the hands that reached out, the
arms that held, the human heart that acknowledged my tears.
How easy to forget Your love that taught me during that time, That
brought me through the waters of circumstances threatening to engulf me.
Lord, how long have my eyes been blind to her true need? Will I help
her up now?
Will I finally began to bind up her wounds?
Am I ready now to walk with her to a safe place of healing?
Somehow my heart's eyes know I am her keeper.

~ews

CHAPTER XII

THE URGENT NEED TO SEE

*G*od promises that "My people will abide in a peaceful habitation, in secure dwellings and in quiet resting places" (Isaiah 32:18). As the eyes of the Church are opened to see the women and their families who are struggling in the grip of violence and abuse in their homes, it will become apparent that this is a need so great it must have immediate attention.

Violence and abuse ranks as the foremost problem in America. It is also true that substance abuse is an eminent threat to our families however; illicit drug use only paves the way for the ensuing violence that it unleashes in homes across our nation. Attention given to the problem of domestic violence and abuse from the pulpit will bring it front and center so that it is no longer a hidden or unspoken shame.

If one woman, one man or one child suffers from abuse, we all suffer. The effect of domestic violence on families and nations has even been recognized by the United Nations who has declared it the most widespread form of violence throughout the globe. Can we stop it?

Let us declare that it must stop and that we have the only answer to stopping it; *we have the gospel of Jesus Christ who will set the captives free.* This freedom is not just for a few, it is for all who come.

We must reach out a hand to lift up these who are afraid to take the first step to seek out answers within the Church.

When we have conquered our blindness and begun to bring healing to those who do not easily come to our table, we can then begin to reach people in all nations of the world. Domestic violence is an accepted way of life in third world countries. May it never be excused, accepted, denied or ignored in our country or, in our Churches.

The greatest need of all victims and abusers alike is to know who they are in Christ Jesus. When that is not learned early in life, wound upon wound will compound and he or she will be in bondage. Relationships formed by two people in bondage have a high probability of ending in disaster. Pre-marital counseling should always include each partner coming to know who they are in Christ Jesus. It should also include an understanding of domestic violence and abuse.

There are thousands of women in shelters across America who do not know who they are in Christ. They struggle with securing the very basic necessities of life and yet, unless someone sacrifices their time and reaches them for Christ, they may never have the opportunity to truly be free. Since they are searching for love, they will continue to find it in places other than in Christ Jesus.

Believers can change the course of the journey of victims by visiting with them, bringing them to Church, loving them as they themselves need love. *Churches have always been the very backbone of America's rich spiritual heritage.* The challenge now is to remove the veil that has hidden to us the depth and reality of need among those who are victims of domestic violence and abuse. We must take a longer look, a harder line, a more tenacious stand.

We must re-affirm often what it means to respect one another. What it means to *prefer* one another, to *hold the other in the highest esteem* (Philippians 2:3 and Ephesians 4: 29-30). These are principles that are readily taught to our married couples but, they *must* also be taught and modeled to our youth, to our children, to singles, and to

the community at large. We cannot afford to assume that the message is getting to those who have lost their way or to those who have never found their way. We must examine whether we are part of the problem. We *can* be part of the solution.

It is not always easy to see into the dark. This book is a challenge to look where you may not have before. Into the darkness that masquerades as happy and whole in the world of women. We do not look because of the very real fear of what we may find, or the fear of rejection or intimidation. Then, there is the sense of hopelessness when the light comes on and we see the stark ugliness of evil. There is also the myth that it will not make any difference if we help remove the evil since more evil may emerge.

It will make a difference to the one you reach. Ask Jesus to open your eyes; so many victims are waiting in the shadows.

TRUE STORIES OF HOPE FROM WOMEN LIVING IN A SHELTER...

They finally were *seen*, by those who served them.
(names are changed)

DIANA'S STORY:

Diana was desperate to find a place to go and heal from horrible burns over much of her head and neck. There was no "home" for her. The burns had come from her boyfriend and she could not go back there. She was scared. She had never had to live in a 'Shelter' before. She was certain she could not adjust to living with women she did not know.

Finally the social worker found a place for her. It was a tiny antebellum home not far from the hospital that kept a few beds for single women who were homeless or escaping abuse.

Throughout her nearly forty years Diana had gone from one relationship to another. It had been over a year since she had talked with either of her children. She was afraid she would never again have the opportunity to see them. Maybe they didn't want to talk

with her. Sometimes she thought darkly that it might have been better not to have lived through the nightmare. She knew too that she was far from being over it.

She arrived at the quaint little "turn of the century" home and was graciously welcomed even with her head swathed in bandages. As she was shown to an upstairs bedroom that housed three other women she felt terribly alone. She did not want to share her story with any of these women, would they be demanding? How long could she avoid them? Would they taunt her and make fun of her? Would she frighten them? How would she be able to sleep?

She was not asked to do anything except rest. Later, she was asked if she would like to come down to dinner followed by a movie. She did not but one of the ladies brought hot tea. She began to relax just a bit.

A couple of days later she was able to share her story with the Women's Supervisor who spoke with a gentle, almost wispy voice. She did not pry; she simply asked questions about the facts. Diana told her of the fight that led to her boyfriend dumping a large tub of steaming hot water over her. Her hair was gone except for a small band that ran from one ear to the other across the lower back of her head. Some burns appeared on her hands and arms, etched there when she had defended herself. She cried softly when she explained that the police had not found him yet. "A neighbor heard me screaming and rushed over and called 911."

Weeks later with the help of the supervisor, Diana set some goals. She chose to get her GED and try to find a job once she had found a wig to wear. A stranger donated the wig. It was long and thick and fell in soft curls across her shoulders. Because of a ready smile, Diana was easy to get to know even with all the hurt inside. Slowly, the hurt was responding to love.

It has been over a year now; she has her GED and a job. Diana is also healing spiritually and is a testimony to what Jesus Christ can

do for the broken. She is beginning to make reconciliation with her children as well.

Interestingly, Diana does not wear the wig while in the shelter. She is comfortable just being herself.

ANGIE'S STORY:

A mother of three, Angie has tried desperately to stay in a 14 year abusive marriage. She has left several times. Each time she was drawn back due to the co-dependent love, the children, and a need for shelter and income. Angie does not have a high school education and feels she absolutely cannot make it on her own. She has been afraid to try to find resources that might help fearing he would find out and beat her. She also expressed that she never felt she would be accepted in Church especially if she went then suddenly began to ask for help.

Angie is overweight, emotionally wrecked, and completely exhausted. She has endured a broken jaw and arm; her jaw healed improperly and causes almost constant pain. She has long since given up on her appearance so that when she came into the shelter her hair and skin was dull, her eyes had no light, and her posture was one of utter defeat.

Her children are confused and crying. They did not want to leave the family dog and they don't want to leave their father even though he is abusive. They are embarrassed and very afraid. They cower and cling to her. All four are under twelve with the youngest still in diapers. She has nothing with her but her cell phone, $50 in cash, and three bags of clothing and other items. Identification and school cards are in her purse. She has managed to get the keys while her husband is in a drunken stupor and has driven out of the county in order to put distance between them. Her cell keeps ringing; he has realized she and the children are gone and keeps pleading for them to come home.

Her parents were unable to help as their resources are very limited and they are over 500 miles away. Her father feels she should stay and 'work it out.'

Only two months have passed and things have changed remarkably for Angie. She has a large two-room furnished suite for herself and her children. They have been placed in a local school with strict guidelines on who can visit or pick them up. They have been given new clothing and toys and books and have access to a large playground area and a beautiful daycare. There are other children their age and fun activities to take part in. Mom has enrolled in GED classes, is receiving regular counsel and has begun to attend Church. She and the children have felt very accepted as this particular Church works closely with the shelter and makes the residents feel at home. Angie has a volunteer mentor who has helped her begin a weight loss and exercise plan. She had to give up her cell phone temporarily and is not allowed to contact her abuser. It has made life simpler. Donated services also gave her a make-over! The first three weeks Angie was encouraged to rest a lot. With the kids in school or daycare she had time to focus on herself and her future. It was the miracle she needed.

PHYLLIS'S STORY:

Phyllis is a beautiful African- American with five children. She came to shelter four months ago fleeing an abusive marriage. For almost ten years she has endured beatings, abandonment, isolation from family and friends, and destruction of almost everything she held dear. For example, Phyllis has no pictures of her family or children because her husband burned them in a rage of anger.

Phyllis is intelligent, articulate and charming and was able to complete two years of college prior to getting married. She has left several times but feels firmly that this is finally it. She won't go back.

She has begun classes at a local college to complete a degree in

social work. Phyllis is a great mom and keeps a good eye on the five little ones. The oldest is nine. She expresses that she does not know what would have happened to her if there had not been a longer-term place to go. She had gone to a 30 day shelter to begin with and found it very constrictive and uncomfortable because of lack of privacy and space. Thirty days was not long enough to begin to make and reach goals; the two-year residential shelter is a blessing. A security gate and alarm system makes her feel safer. Counseling has made her realize she is doing the right thing and case management has outlined her goals to independence.

LANAI'S STORY:

Lanai is a 5"1, 100 lb blond 18 year old. At 16 she brought charges of sexual molestation against her father. Her court report begins: "Victim states suspect (her biological father) has been sexually abusing her for over four years. He comes into her bedroom 4 or 5 times a week after her mother has gone to sleep or work and begins to touch her private parts underneath her clothing. She states she pretends to be asleep because she does not want to make eye contact with him. That way she can believe it is not really him. He then began to penetrate her and she could not longer pretend. She and her mom went to the police." Mom agreed to allow the father back in the home!

The court put the father on probation and allowed him to live in the same house with the mom and the sixteen year old! From sixteen to eighteen Lanai's father continued to molest her. She felt trapped because Mom had essentially given in to the dad. She became pregnant with his child and ran away.

Lanai went to the home of a friend who called the local police. Police brought her to a Shelter and are working with her to bring charges against her dad. At the shelter, Lanai has support and guidance from the workers and from other women who are there. Since it is a long-term shelter she can stay throughout her pregnancy and

delivery and at least another year. She will be encouraged to continue her education and complete getting her diploma. The plan would be to help her develop job skills, go on with college, get a car, and work toward living independently. She will have the counsel necessary to learn how to deal with the trauma she has endured.

KATY'S STORY:

Thirty year old Katy had come to the shelter from a drug-rehabilitation facility. She had completed their program so needed another place to stay. Katy had learned to depend upon drugs to kill the pain of abuse from her boyfriend. They had a six-year old boy who was now in foster care. She was still in need of therapy and had behaviors that made it difficult for her to get along with others.

Katy was 'written up' several times in the shelter for stealing, lying, and refusing to follow policy. Soon Katy was asked to leave due to her continually disruptive behavior. Katy really knew she had come to the end of herself. Although she was not using drugs, she realized that her behavior was not acceptable and that if she returned to the outside world she would not be able to stay free of drugs or to get to an independent state of living. The shelter gave her another opportunity to work through their program.

Today Katy has been able to distance herself from her past abuse and fear of her perpetrators. This was what was driving her drug use and unacceptable behavior. Her family was too dysfunctional to be of any help to her. She received counseling and began attending Church regularly. She finished a certificate program in nursing at a local college and found work. Katy's attitude toward life and her own future changed drastically; she was able to hope for the first time in her life. She is now reunited with her son and living independently.

The day she was able to purchase a home through a government subsidy program for herself and her son was a day of miracles and new beginnings.

DEANNE'S STORY:

"If anything should happen to me fatally tonight, please call my ex or my adoptive mother and have them take my son but only on the grounds that if I survive she returns him to me immediately."

That was a note left by 25 yr old Deanne when she ran away from the shelter and left her 2 year old son asleep in her room. Deanne was a very sad case. She was bipolar. She hated taking her medication and often did not. This was one of those times.

Deanne called the next day to check on her son. The ex-husband had been notified and was on his way to pick up the child though he had not received custody. He was familiar with Deanne's bizarre behavior. The reason she was in shelter was due to running away from her adoptive mother's home where she and her son had been living.

There was nothing stable about Deanne but the shelter provided mental health care, medical care, counsel, and Church activity. Since Deanne's medications were monitored by the shelter, she had managed to take them regularly for several months and was beginning to think about going back to school and getting a job so she could provide for herself and her son. Unfortunately, feeling better had led to 'cheeking' her medication. She would spit it out in the bathroom. She thought she didn't need it anymore.

When Deanne called, the shelter offered to come and pick her up and work with her on keeping her son. They had rules though, and Deanne would have to follow them. Sadly, Deanne still felt she did not need the medication and was certain she was going to be able to find an apartment and get a job without help. She was however, just stable enough to know she could not care for her son.

She did not return and the child was placed with the biological father.

KENETTA'S STORY:

27 year old Keneta has been in several shelters. She is terribly afraid of her boyfriend finding her and their 18 month old girl. In a recent shelter she was told he had called and said if he found her he would kill her and then kill himself. When asked the circumstances of her leaving her husband she relates a tragic history of abuse from her boyfriend and her sister.

Her boyfriend, along with her sister, had forced her to engage in sex with other men and with women so that he could video tape sexual acts. He beat her if she refused. "It was beyond horrible," she recounts. She felt she could not leave because she had only an 11th grade education and had never held a job. Her self-esteem and confidence was zero.

Keneta had noticed a slight discharge from her baby girl's vagina then, she noticed dark pubic hair in a diaper. That's what gave her the courage to leave. She had to protect the baby.

Today, Keneta and her toddler are safely hidden in a confidential shelter setting. She is receiving counsel and the baby has received medical care. Keneta is enrolled in classes to receive her GED. Being at the shelter allows her to pursue classes and a job while her baby is cared for in their daycare. She has begun to put distance between herself and her past and work toward becoming a healthy and productive individual who can provide independently for herself and her child.

BEING IN SHELTER CARE

No little girl grows up dreaming of living in a shelter. It seems a very demeaning thing to most women and it likely never enters their minds. It has not even been something that the American society has seen fit to provide until the late seventies. Statistics from that period state that America had more shelters for dogs and cats than for women.

The tide has begun to turn and there are now both secular and faith-based shelters sprinkled across the nation. Shelter care became

more prominent as the abuse of women began to be openly discussed as pioneers in the little known field began presenting solid research about the plight of women. Women and children fleeing domestic violence, and now, homelessness, is the fastest growing segment of our society today. It is a tragic fact in the richest and most benevolent nation in the world.

What can a woman expect when she needs shelter?

There are wonderfully compassionate caregivers who have given themselves wholly to the business of caring for women in need. Few who do not feel this compassion or who are not willing to endure the hard work of care will last. With this in mind, women can expect to find sensitive, intelligent, practical care.

Safety is paramount. Shelters are very confidentially located and often gated. Alarm systems are usually installed to provide even more safety from potential former abusers who may try to locate their victims. Women are instructed to keep the shelter location confidential. Breaking that rule can result in being asked to leave.

Shelters stay can be anywhere from overnight, to three days, thirty days, ninety days, or up to two years. The longer the stay the more able the woman is to stabilize. There are privately funded shelters and shelters that subsist on government or community grants. There are secular and faith-based shelters.

The difficulties of living in shelter can be multiple. Usually living in community with other women and their children is the hardest change to deal with. Women will sometimes go back to their abuser rather than deal with the relationships and the problems of living with strangers. The women in shelters are from various backgrounds, levels of education, society, and experience. Some do not have balanced personalities due to the unhealthy experiences of their lives. It is foreign to many to be in this mix.

Another difficulty is giving up personal space. Shelters are often overcrowded and a woman may only have part of a small bedroom, perhaps nothing but the bed itself to call her own. There may be

no closet space in smaller shelters. Sometimes a woman has nothing but garbage bags to live out of. It is the goal of larger and better funded shelters to give each woman some privacy and space for her own things. When a woman is in an emergency however, there is no time to choose a shelter that has all the right things. Shelter is shelter in this case and she can always move to a more comfortable place later. She will at least have a safe place to sleep and food to eat.

Shelters provide food, clothing, medical care, and education for their residents. Public school for older children and daycare for babies and toddlers is also provided. Counsel, both secular and biblical, is usually provided to allow a woman to stabilize and grow.

It is important for women who are experiencing situations that may call for them to leave in the middle of the night to take time beforehand to check out suitable shelters. This will have to be done from a location where her abuser will not be able to see that she is checking. A library can be a suitable place. The local police department, Human Resource department, or YWCA will be able to help as well.

It is important for a woman in shelter to be willing to follow rules. To keep a community of women and their children living in peace and harmony requires policies and protocol. Shelters will generally have a handbook of these that are given to a woman at intake. She will have to realize that everything is scheduled in order to keep the shelter running smoothly. Transportation is scheduled, childcare is scheduled, eating is scheduled, watching television or using the computer is scheduled, classes on job readiness, parenting, domestic violence, healthy boundaries, and a myriad of other subjects are scheduled. Respectful adherence of that schedule is a vital key to a woman's successful stay.

The benefits outweigh the downside. Learning to live alongside women with similar experience can be encouraging. Often women feel they are alone in their story of survival. Learning to grow spiritually and personally is an opportunity many would never have had. Counsel with educated and experienced shelter staffers will ensure

success on the road to independence. It is also very important to be in community when a woman is tempted to return to her abuser. She will find support to sustain her is a better choice than to go back.

Most shelters have programs that allow a woman to grow to independence at her own pace. As she becomes stronger and more able to make good decisions she may be able to move into a transitional shelter apartment. This is a great step toward independence. She still has oversight but will live privately instead of in community.

It takes a great deal of courage to place yourself in the hands of others. Women whose level of trust has been shattered already have a difficult time doing this. When they do, they are to be congratulated and reminded daily that they have made a good choice for themselves and their children.

Women need to be educated about what to expect in shelter and how to survive it. People who have compassionate hearts need to seek out how they can work in shelters or assist in encouraging women who find themselves in care. The stigma needs to be removed but it only can if there is education and awareness of the need for highly accountable and productive shelter care that provides for the whole woman and not just basic needs.

FINAL SUMMARY

omestic violence and abuse has found inroads into the fabric of Christianity in America. The fabric has weakened from the silence of the Believer. There has been a significant failure by clergy to openly address abuse happening in families in Churches. This failure has allowed the enemy to penetrate and set up camp within the very walls where refuge should be found. Women are silenced, hushed, told to go home and be a better wife and, they have become the tragic statistics. These statistics do not just reflect the world outside the Church but the Church from within. The Church must share responsibility for embittered and shattered lives, crushed and disillusioned spirits. Grief unmourned hardens the heart. Once lovely and fresh of spirit these women harden into unfeeling stone.

Knowledge about the issues surrounding domestic violence and abuse is either lacking or not publicize in most Churches. Not only is the pulpit rarely used to expound on these issues, misuse of power often surfaces when the spiritual counselor becomes the perpetrator and re-victimizes the woman. Often, he has confused his role with "savior" to her loneliness and pain. He may even allow himself to feel good about sexual intimacy with the counselee but ultimately, he is only enjoying his power over her. In the last decade, the center for the Prevention of Sexual and Domestic Violence in Seattle, Washington, having only been open less than two years, reported that it had

responded to nearly 2000 instances of clergy abuse.[12] Is the message that the woman is always seen as an object of use and no accountability is executed for the perpetrator even within the Church?

According to the National Domestic Violence Hotline, domestic violence refers to a pattern of violent and coercive behavior in an intimate relationship exercised by one over another. In clergy betrayal, it is still power and control over another individual; it violates the very heart of ministry. Abuse always takes the form of at least one, or perhaps all four, of the recognized types of abuse: Physical, sexual, psychological, and assault against property.

Only in the last fifteen to twenty years has domestic violence and abuse begun to be recognized as very serious and challenging issues in American society. It will take much longer in third world countries where archaic and heart-breaking practices force young girls into arranged marriages at an early age or into prostitution to provide food and shelter for the family unit or for themselves. It is now called "human trafficking" but it is the continuing plague of violence against women.

Historically, men and clergy have not been held accountable. In the book "Between Pit and Pedestal", the author brings to light how women fared in physical and sexual assault cases during the middle Ages. Women were actually punished for inciting assaults "against themselves" while men went uncensored. The author concludes that this was due to a male dominated society.[13]

Secular organizations have been first to pave the way for recognizing and preventing the problems of violence and abuse in relationships in and out of the home. These organizations have identified the problems of abuse and have taken steps to shelter and assist victims as they are restored to society. The Church has the only perfect hope for these victims in Jesus Christ yet, it holds that

12 Fortune, Marie M., and James N. Poling. Sexual Abuse By Clergy. Eugene, OR:Wipf and Stock Publishers, 1994, p.1.
13 Williams, Marty and Anne Echols. *Between Pit and Pedestal*, Women in the Middle Ages. Princeton, NJ: Markus Wiener Publishers, Inc. 1993, p. 164.

answer on a level the victims cannot attain, *the level of social acceptance*. Domestic violence and abuse is not going to go away quietly, it will not go away if ignored; horrific tragedy is the harvest already being reaped.

What should be the response by believers? It must be practical, sensitive and compassionate caring. Anger at the injustice of violence and abuse in the home is not enough, public action by the Church must be taken. First, Churches must dispel the myths that have long prevailed as truth:

God hates divorce. Yes, He does but, more than that, He hates the violence perpetrated by man that leads to divorce (Malachi 2:16).

But he is such a wonderful person! Abuse happens privately, not publically. Behind closed doors the man who just shook your hand at Church may be belittling, degrading, or battering his wife. Who will she tell? Who will believe her? Who will be her advocate and encourage her?

I don't see bruises! A batterer attacks the areas of the body not seen or areas easily covered by clothing; the trunk, the genitals, upper thighs and arms, buttocks and chest.

What if I am wrong? What if you are right? If you are sensing a problem, ask! Better to be wrong than to risk her loss of life, limb, or personhood.

One in every three women in America are violated or abused in some fashion. Ninety-five percent of victims are women which is why this article refers to women and not men. According to statistics from the Department of Justice Bureau of Justice, 2000-2003, physical violence occurs in four to six million relationships each year in America alone! Out of cases actually solved, thirty-three percent of all women murdered in the U.S. are murdered by an intimate partner. Domestic violence affects all races both male and female. The highest rates reported are among African-American and Hispanic women. These are only a few of the grim statistics. An untold number of assaults go unreported out of fear of what could happen

to the victim or to their children if they tell. Worst are the silent victims, the children. Their voice is sometimes never heard and yet they are the most likely to continue the cycle of abuse as adults.

The cost to Christianity is incalculable; the destruction to the body of Christ cannot be measured. The cry of God's heart is the same now as in the days of the prophet Jeremiah: "You have healed the hurt of the daughter of my people slightly, saying peace, peace; when there is no peace" (Jeremiah 8: 11). Still the weeping of the desolate breaks His heart as when Tamar, raped by her half-brother Amnon, went out from the bedroom where she was ultimately rejected and despised, and wept. The Scriptures say she "remained desolate" (II Samuel 13: 12-30). Victims of abuse remain desolate in their hearts all of their lives if they do not receive healing.

The greatest need of victims and abusers alike is to be brought into restoration and fellowship in the Kingdom of God through the good news of the gospel. This is what believers can do. The good news is not just for those who come regularly, who look right, talk right, and walk right. It is for those who are not quite a "fit" even when and if they do begin to rise above their shame and reproach. It is for those who do not dare come because of the added rejection they may feel. It is for those who are in jail, in hospitals, in the streets. The "Good News" must be spread into the whole market-place of the world outside the Church without regard to race, gender, past history or present circumstance.

Most of all, the blinders that make this shameful tragedy stay hidden must be removed. The Church must hold abusers accountable, *even, and especially if, it is their own clergy*. They must declare zero tolerance for abuse and openly educate and support the victims. They should partner with local community centers who are already reaching out to these who so desperately need healing and restoration. The body of believers each holds the true miracle of healing and hope; it must be given to these victims.

Victims (and abusers) are people who often do not know who

they are in Jesus Christ. Will you tell them without judging or condemning? Will you walk alongside them in dusty and rutted roads as they journey to wholeness? Will you welcome them into your fellowship without regard to their past? Will you fight for justice, confront and restore abusers, and hold out the lifeline of consistent love and compassion to them?

All of this seems so much easier when it is in another part of town, in another community, another Church, even another part of the world but, it is not. Open your eyes and look within the walls of your own community of faith.

SUGGESTED READINGS:

Alsdurf, James, and Alsdurf, Phyliss. Wife Abuse and Scripture. In Abuse and Religion: *When Praying Isn't Enough*, ed. A. Horton and J. Williamson, pp. 221-28. Lexington, Massachusetts: Heath Publishing.

Bennett, L. W. Substance Abuse and the Domestic Assault of Women, *Social Work* 40: 760-61, 1995.

Bingham, C.F., Ed. Doorway to Responses: The Role of Clergy in Ministry With Battered Women. Springfield, Ill.: Illinois Interfaith Committee, ADV, Illinois Conference of Churches, 1986.

Bussert, J.M.K., Battered Women: From a Theology of Suffering to an Ethic of empowerment. New York Lutheran Church of America, 1986.

Cantos, Arthur L., O'Leary, Neideg, and O'Leary, K. Daniel. Injuries of Women and Men in a Treatment Program for Domestic Violence. Journal of Family Violence 9, no. 2: 113-24. 1994.

Dobson, James C., Straight Talk: What Men Need to Know; What Women Should Understand. Dallas: Word, 1995.

Fay, Jennifer. He Told Me Not to Tell. Seattle: King County Sexual Assault Resource Center, 1979.

Fortune, Marie. <u>Keeping the Faith: Questions and Answers for the Abused Woman</u>. San Francisco: Harper, 1987.

Gerhardt. Elizabeth. <u>Martin Luther's Theology of the Cross: Cause or Cure of Domestic Violence?</u> Th.D. diss., Boston University, 2000.

Lance, Deborah J. Pope & Engelsman, Joan Chamberlain. <u>A Guide for Clergy on the Problems of Domestic Violence.</u> Trenton, N. J.: Department of Community Affairs, Division on Women, Domestic Violence Prevention Program, 1987.

McDill, S. R. and McDill, Linda. <u>Shattered and Broken: Wife Abuse in the Christian Community: Guidelines for Hope and Healing</u>. Old Tappan, N. J.: Revell, 1991.

Felder, Raoul and Victor, Barbara. <u>Getting Away With Murder: Weapons for the War</u>

<u>Against Domestic Violence</u>: New York, NY: Touchstone, 1997.

BIBLIOGRAPHY

Allender, Dr. Dan B. and Dr. Tremper Longman III.
Bold Love. Colorado Springs, Colorado: NavPress, 1994.

Katz, Jackson. The Macho Paradox. Napierville, Ill: 2005.

Kroeger, Catherine Clark and Nancy Nason-
Clark. No Place for Abuse. Downers
Grove, Illinois: Intervarsity Press, 2001.

Olmoguez, Violeta. Pastor's Handbook on Domestic Violence.
Jacksonville, Florida: Zoe University, 1998.

Williams, Marty and Anne Echols. Between Pit and
Pedestal. Women in the Middle Ages.
Princeton, N.J: Markus Wiener Publishers, Inc. 1993.

**FOR HELP CALL
THE NATIONAL DOMESTICE
VIOLENCE HOTLINE**

1-800-799-SAFE OR 7233

ENDORSEMENTS:

1. MRS. PATSY RILEY, FIRST LADY OF ALABAMA, 2002-2010, MONTGOMERY, ALABAMA.

I feel very inadequate to write a single word on domestic abuse since I neither grew up in that environment or lived in any kind of abuse in my 45 years of marriage. But I can endorse a book that will help empower any woman living in abuse. Also, I can certainly endorse a book that can help to educate women not to fall into the trap of abuse. The red flags are there. This book, "Do You See This Woman", will help women see their future without abuse.

2. DR. BRENT MCCLARTY, MD. FAMILY PHYSICIAN, CHELSEA, ALABAMA.

Liz Sherrell is my valued patient and friend whose insight and faith has always been an inspiration to me. In her book, *Do You See This Woman*, she takes the sensitive issue of spousal abuse squarely by the horns and directly confronts the church's role in addressing this issue, particularly in its shortcomings and responsibilities.

She offers challenging solutions to complex issues but ultimately places the problem at faith's door where it belongs. I recommend her book to anyone who is serious about finding new solutions to this age old problem.

3. ELAINE GENTRY, FOUNDER AND PRESIDENT, TENDER MERCIES MINISTRIES, CHELSEA, ALABAMA.

This book has been inspired by the love of the Lord for His hurting children. While the world, and sadly, sometimes the Church, may overlook victims of abuse, the Lord is ever mindful of them. Liz Sherrell is someone the Lord has found willing to use her life to help. Many years of experience has gone into the writing of this book. My prayer is that many who read it will be encouraged to help as Liz has been willing to do most of her life. Thank you Liz, for this book, and for giving so much of yourself to help these people in need.

4. REV. KEITH G. POWELL, PH.D, REGISTRAR, ZOE UNIVERSITY, JACKSONVILLE, FLORIDA.

We have come to the time in our society and world that it is necessary to increase the "Church's" awareness of the unpleasant truth of what is happening in our churches, homes, and communities. Mental, verbal, and physical abuse is running loose within our culture today and the church is not exempt from its effects. Liz Sherrell's desire to step out and confront this issue within our churches should be applauded. The church has sat down long enough. It is time to stand up and be counted.